*The Simon and Schuster
pocket guide to*

Painting in
Oils

Series Consultant
Diana Armfield MSIA, NEAC, RWA, ARWS

Simon and Schuster
New York

Series consultant	Diana Armfield MSIA, NEAC, RWA, ARWS
	Painter, Visiting Lecturer at the Byam Shaw School of Art, London and Editorial Consultant for *Leisure Painter* magazine
Consultants	Robin Child NDD, ATC
	Painter and Director of Art, Marlborough College, Wiltshire, England
	Peter John Garrard VPRBA, RP, NEAC
	Painter, Editorial Consultant for *The Artist* magazine and Head of the Painting Department, Mary Ward Centre, London
	Ken Howard ARWS, ROI, NEAC
	Painter and Editorial Consultant for *The Artist*

Acknowledgements

The publishers would like to thank Winsor and Newton Ltd for their advice and for the materials they supplied. We would also like to thank the following for their assistance: Tam Giles, Janel Minors, David Morris, Marc Winer, W. Taylor Frames Ltd.

Line illustrations by Coral Mula, with additional illustrations by Russell Barnett, Marilyn Bruce and Elaine Keenan.

Picture credits are listed on page 144.

Chief Contributing Editor Carolyn King
Art Editor Linda Cole
Contributing Editor John Roberts
Assistant Editor Susanne Haines
Picture Researcher Brigitte Arora
Editor in Chief Susannah Read
Executive Art Editor Douglas Wilson
Production Sarah Goodden

Edited and designed by
Mitchell Beazley International Limited
87–89 Shaftesbury Avenue,
London W1V 7AD

© Mitchell Beazley Publishers 1982
All rights reserved
Typeset by Tradespools Ltd,
Frome, England
Color reproduction by Reprocolor
Llovet S.A., Barcelona, Spain
Printed in Hong Kong by Mandarin
Offset International Ltd

Published by Simon and Schuster
A Division of Gulf & Western
Corporation
Simon & Schuster Building
Rockefeller Center
1230 Avenue of the Americas
New York, New York 10020

Library of Congress
Cataloging in Publication
Data Armfield, Diana.
The Simon and Schuster pocket
guide to painting in oils.
1. Painting – Technique.
1. Title.
ND1500.A68 751.45 81-16613
ISBN 0-671-42473-4 AACR2

Introduction

This book has been compiled from discussions held between several painters, all of them widely experienced in both the practice of painting and in teaching art students. They have very different viewpoints but all share certain fundamental principles about the teaching of painting.

One of these is that the actual experience of painting will teach a student more than any written or verbal advice on how to tackle a particular problem, however helpful it may be. Another is that almost any assertion made about painting is sure to be open to contradiction. What is true for one artist may be entirely wrong for another. Thirdly, and most importantly, all the advice given in this book is intended to open the reader's eyes to the possibilities, not to lay down hard and fast rules that must be followed.

Most painters want to share the knowledge gained from experience. The desire to impart helpful advice has led to the use of such phrases as 'you must' or 'you ought', but these should be taken as invitations to verify the advice through experiment. None of the points made are indisputable laws.

There is an artist in everyone. Use the advice in this book to develop your own talent, in the directions that suit you best, rather than copy another's.

Diana M. Armfield

Contents

How to use this book

Everyone has the ability to paint – it is just a question of releasing your talent. This guide will help, by showing you the methods and techniques you will need to achieve specific goals. By following its systematic instructions, step by step, you will learn how to develop your skills in a fascinating medium.

The book is divided into three main sections: on materials, on techniques and finally a reference section that includes advice on making and obtaining materials, and protecting and storing pictures. There is a glossary to help you understand technical terms used in the book and also cross-references at the top of the page. Use these to find explanations of techniques referred to and to find additional relevant points.

The *Pocket Guide* is designed to be read and studied at your leisure to build up your knowledge of the approaches, methods and techniques of oil painting, but it can also be taken with you into the studio or on painting trips as an essential part of your painting equipment, to be referred to as you work.

Materials

An understanding of the materials used in oil painting is very valuable. Oil paint is versatile and beautiful, and in order to exploit its potential to the full you need to know just what it can and cannot do. In this section, you will learn about the pigments and the medium with which they are applied, the different kinds of painting surface and their methods of preparation, the different supports for use in the studio and the field, and finally the first steps in preparing to paint.

Techniques

This is the most important section in the book, covering the principles of color and light, and the actual processes of putting paint on the surface of the picture. Detailed steps take you through all the stages – from inspiration, through composition and into the handling of paint. The main types of subject and the different problems they involve are discussed. This is not painting by formula, however, and the section ends with some of the broad factors that make for truly original and powerful artistic expression.

CONTENTS

Reference

The *Pocket Guide* is completed by a section containing useful information for the painter beyond the business of putting paint to canvas. Making your own paints, mediums and size is considered, together with the important questions that arise after a painting is finished – protecting the surface, framing and storing.

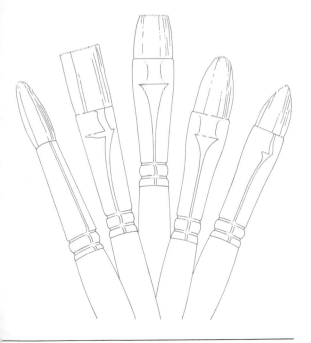

Materials

Top row: paints. **Second row:**
natural bristle and sable brushes;
painting and palette knives. **Third
row:** turpentine, linseed oil,
mediums. **Bottom row:** palettes.

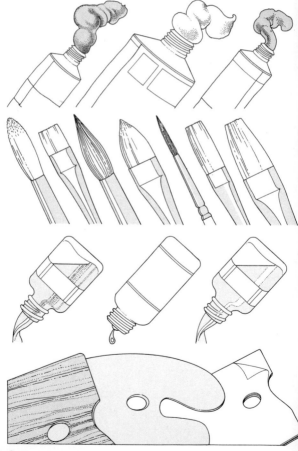

An art supply shop displays such a bewildering array of specialist materials that, unless you are armed with a knowledge of what advantages each has to offer, you will not know what to choose. On the following pages you will find information on all the basic equipment commonly available and recommendations for what you will need to start you off. From this you will soon discover, by trial and error, what suits you best.

One basic rule that should guide your choice of equipment is not to make false economies. The difference between natural and synthetic bristle brushes or between linen canvas and cotton duck, although not always apparent with your first efforts, may soon hamper your ability and even spoil your enjoyment. Good materials last a long time and are responsive. Painting is difficult enough as it is, so don't ignore the extra help they give.

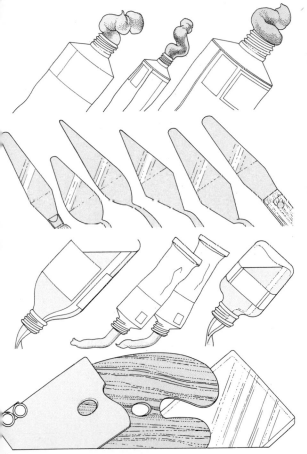

Canvas

The word canvas can describe a finished oil painting as well as the material or 'support' on which an oil painting is executed. This support consists of either canvas stretched over a wooden frame; wood or composition board cut into panels; paper; or cardboard. In each case the support carries a ground. This has two elements: size (a glue) which seals the surface, and primer (an undercoat) on to which the paint is applied.

The best canvas is linen, distinguished from the inferior cotton by its natural color (cotton is white or very light). Top quality linen comes from Belgium and Ireland. For economy, practice, experimentation, or when painting on a large scale, cotton canvas is quite acceptable but it has several drawbacks: it suffers from fluctuation in tension which makes it flap about in wet weather and tighten up in the dry; it stretches badly compared to linen; it is not quite as tough; it rots faster; it needs the wedges or keys constantly driven in to keep the surface taut; and many painters do not consider it as responsive as linen.

Although linen is unquestionably the best support, many people start off with primed cotton on stretchers. Both linen and cotton are available in various weaves and qualities in three states: 'raw' (unprimed) or ready primed in rolls or primed on stretchers. You might weigh up a number of factors when choosing a texture from fine to coarse: the subject, its scale, how you will apply the paint and, most important, what you *like* to paint on. If you enjoy thick paint applied with a knife, you will find a coarse canvas has a better 'tooth' to anchor the paint. If you use a sable brush and build up with tiny brushstrokes, a coarsely woven canvas will swallow up the paint so that here a fine texture is preferable.

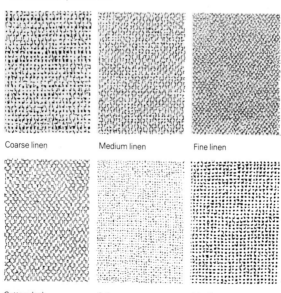

Coarse linen Medium linen Fine linen

Cotton duck Calico Muslin

Choosing canvas

Poor materials may have a dressing or filler which gives extra 'body' and weight.

Choose raw linen without knots, and cotton that has no rough flecks.

Broken or uneven weave, or too much stretch on the bias, is undesirable.

Buying canvas

If buying raw canvas to prime and stretch yourself, go to a reputable art supplier or, ideally, you might be able to find a sailmaker or canvas supplier who stocks a variety of grades and widths. Choose the width that will cut up with the least wastage for the size and shape you want to paint. Offcuts can be glued to hardboard. Avoid materials composed of mixed fibers such as linen/cotton which stretches unevenly. Good linen has a tight weave of even threads which will persist through several layers of paint and remain firm under the brush; on cotton the texture quickly becomes obscured and the surface rather flat. Ready-primed linen or cotton by the yard is reliable, comes in various textures, and is convenient and quite economical to stretch yourself.

Canvas on stretchers

Commercially primed, stretched canvas is consistently even in quality and quick to get started on. However, once having acquired some skill, it may feel rather more greasy than the canvas you prime yourself, but this is a matter of taste. Price, and restriction to the available sizes and shapes, are other drawbacks. Oil- and acrylic-primed canvas come in a choice of grades. (The durability of acrylic primer under oil paint is still in doubt.) Standard sizes range from 10×12in (254×305mm) to 36×48in (914×1219mm) at intervals of 1 or 2in. Large sizes are held rigid with crossbars.

Alternative supports

Any natural fabric, pale and unpatterned, such as worn linen, cotton tablecloths, muslin, or canvas offcuts can be glued to board. Tailors' canvas is a cheap, pure linen interlining. Hessian has a dominant texture and needs much sizing. Old canvases are fine to paint on if scraped down.

Tailors' canvas

Hessian

Boards

Mahogany, for centuries the traditional wooden support, can no longer be relied upon to be well seasoned and not to warp, and is now so expensive that it has been superseded by a large number of more economical wood or composition boards. These can be painted on direct or covered with a plain natural fabric, and are usually primed with either gesso, with an egg emulsion, or with an oil undercoat out of a can. Paper has been used as a support since 1400, and cardboard panels of paper pulp, or combined with wood or cloth, date back to the sixteenth century.

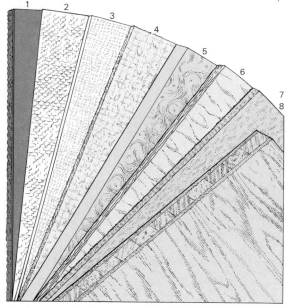

Boards are practical and cheap: they are durable, often light in weight, and come in varying thicknesses in large sheets, many of which can be cut with a mat knife into a dozen panels. The tooth or textured surface varies enormously, from masonite (1) with none at all (sanded and sometimes covered with fabric) to strawboard (5) with a pronounced tooth which wears out brushes quickly. Oil painting paper (2) or heavy rag watercolor paper, sized with skim milk to reduce absorbency, or washed with turpentine, is lovely to paint on, as opposed to brand name oil painting boards (3), some of which are cotton covered, others have only a simulated canvas texture producing a rather harsh, mechanical painting surface. This can be improved by an extra coat of primer but remains far inferior to fabric-covered board prepared at home (p17). A light composition board (4) which does not chip or warp has a pleasant painting surface. Heavy duty cardboard (6) and wallboard (7) are not very durable; they should be well sized. Composite plywood board (8) is strong but heavy, and best limited to small panels. Although ideally all boards should be sized, some primers are adequate sealants.

Preparing boards

On paper, cardboard or wood panels the image can grow in any direction, to be centered and trimmed later. White cardboard or paper is sized only. Colored panels are sized, then painted on direct as a toned ground or given a thin coat of white primer.

Cardboard should be backed with another sheet to prevent buckling. Glue with contact cement or size using a cardboard glue spreader.

When dry, both sides of the panel must be sized to prevent impurities in the cardboard persistently rising through to the surface of the paint.

Battening masonite

Normally the frame will prevent a medium-sized board from warping or twisting. Sometimes you can simply choose a heavier board. Generally, panels of more than 30×40in require bracing with seasoned wood, and you may also have to add a crossbar for rigidity.

1 Cut four lengths of 1×2in wood to the same dimensions as the panel. Join them up.

2 This frame can either be glued to the wrong (ie textured) side of the board with strong adhesive (even after you have painted on it) and clamped, or tacked on with small nails.

3 Drive in the nails at 2in intervals around the perimeter of the right side of the board.

4 Countersink the holes and fill with plastic wood. You may have to do this twice.

5 When the filler is dry, sand the edges and the shiny surface to give a tooth for the size.

Stretching canvas

The most important property of good canvas is that it should be flexible enough to be stretched taut over a wooden frame or stretcher, yet when sized and primed should shrink sufficiently to present a responsive and sympathetic painting surface. Cotton, however, expands and contracts according to humidity levels. Synthetic fibers, despite claims to the contrary, so far are unable to imitate the special 'feel' and texture of real linen.

Stretcher bars vary in length, width and also in the shape of the bevel, a modern refinement which prevents the edge of the stretcher marking the canvas. Some stretcher bars are beveled on both sides, some on one side, and old European ones were not beveled at all.

The weight of the stretcher should reflect the size of the picture – the bigger the canvas, the stronger the stretcher. You will need a stretcher with a crossbar for a 24×36in (609×914mm) upward, and a double crossbar for a 36×48in (914×1219mm) and up. Otherwise, when you pull on the canvas, the stretcher may come apart. There is usually a sharp edge and a beveled edge to the outside of each stretcher bar. All four bevels must face in the same direction otherwise the sharp edge is likely to cut the cloth.

Assembling the stretcher

Push each mitered joint together, the beveled edge uppermost. Tap the corner gently with a piece of wood or a mallet for a snug fit. Once correctly assembled, mark the joints in pairs of letters: AA, BB, CC, DD, in case the stretcher is re-used.

Stretching unprimed canvas

Is the stretcher square and true? Measure the diagonals with a length of string. If they are equal, the frame is square. A set square ensures precision but a rough check can be made by placing the stretcher on the corner of a table. Assemble canvas, mat knife, steel ruler, hammer and steel tacks. (A heavy duty staple gun is effective when stretching canvas alone or when stretching a very large canvas.) Place the frame, beveled side down, on the linen, aligned with the grain of the fabric. With the knife, cut the cloth 2in larger than the stretcher on all four sides.

With the stretcher upright, fold the fabric over and, leaving tacks halfway in to allow for adjustments, drive in the first one in the center of a long side, pulling the canvas firmly and evenly; it must stay square with the wood. Then turn and tack on each short side.

The stretching sequence

Following the diagram, work out from the center, placing tacks about 2in apart. Do not tack right up to each corner, as they are finished later (see below). Unprimed canvas should not be pulled too taut; the size will shrink it and it may then split, or distort the stretcher. Do not underestimate the skill needed to pull the canvas, hold the tack, and hammer it in, all with one pair of hands.

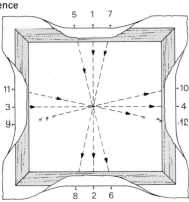

Handling the corners

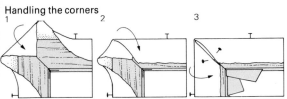

1 Pull the cloth across the corner of the stretcher, **2** fold in each side of the cloth smoothly and neatly, and **3** tack down both flaps. Finish the other corners, putting in the final tacks about 1in from each mitered joint, through the thickest part of the wood to prevent it splitting. Drive all the tacks home. Now lodge two wedges or keys temporarily in place in each corner: the longest side lies along the wood of the stretcher. If they are put in the wrong way round, they will split when hammered in against the grain. Do not drive them in tight for at least a year after the picture is finished as it will take this long for the paint to dry, and only then if the canvas becomes slack. Cotton is likely to need constant adjustment but linen remains taut.

Stretching primed canvas

Primed canvas is perhaps more difficult to stretch than raw: it is less flexible and requires a special tool – a pair of canvas pliers. Choose a piece of blemish-free, oil-primed canvas. Following the method for raw canvas, cut it out and attach it to the stretcher. You will need to pull quite hard on primed linen as, unlike raw canvas, it will not shed any final wrinkles by shrinking during sizing, but if you pull too hard on primed cotton canvas you will crack the ground. Canvas pliers give the extra leverage on the material; a staple gun is an advantage if attempting the job alone.

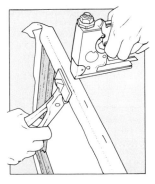

Size

Stretched canvas, board and other supports must be sealed before being used. This can be done either with an acrylic ground (see p19), or by the more traditional method of sizing and priming. Glue size is derived mainly from animal hides or from technical gelatin. It acts as a separating membrane, isolating the support from oil in the paint and ground. Without size, this oil would seep down and 'rot' the canvas, leaving the paint impoverished, and in time, flaky.

All supports that are to have a non-acrylic ground need two thin coats to receive the primer, and to discourage impurities from rising through to the paint, or damp penetrating from the back (varnish protects the front). Rabbit skin glue (which comes in crystals, granules or sheets) best combines flexibility with sealing qualities.

Preparing size

1 Put one rounded tablespoon of crystals into a 1lb jam jar and let the contents soak in enough water to cover for about 20 minutes, when it will have doubled in bulk. Fill the jar three quarters full of cold water and stand it on a lid or trivet in a saucepan of warm water.

2 Dissolve the crystals over a gentle heat for about 30 minutes, stirring occasionally and never allowing the size to boil or the pan to go dry. You could also heat it in a coffee can standing in water or in a double boiler, but in a glass jar you can see when the crystals have dissolved.

3 Let the size cool, forming a jelly. Don't stand it in cold water to do this or the jar may crack. Test it with a finger – you should just be able to break the surface, and it should not fall out if the jar is inverted. If too solid, reheat the size, add water, and allow it to reset.

Sizing canvas

Dissolve jelly by standing the jar in a pan of water over low heat. Apply size lukewarm with a 2in brush to the right side of the canvas, starting on the short side. Work from the edge in one direction only. Smooth the glue uniformly over the surface, including the edges. Keep the brush loaded but do not scrub it in or pile it on. If the size is too hot or is pushed in, it will form small bubbles or pinholes and soak through; if it is too strong, the ground will crack. Leave the first coat to dry for several hours, lying flat. Brush on the second coat in the opposite direction. As it dries, run a palette knife around once or twice between stretcher and canvas to make sure that they do not stick together. Wash the brush in warm water after each coat.

Sizing and preparing masonite

Sand the shiny side and size both sides. Dry flat, then apply a second coat. It can either be primed (p130), or covered with fabric before priming.

1 Take a sanded panel that is cut square and true and lay it down on top of the clean material. Cut a margin 2in larger all round than the board. Trim off any loose threads.

2 With lukewarm size and a household paintbrush, size the right side of the board, then smooth the fabric over it, keeping the weave parallel to the edge.

3 Now apply more size to the cloth, brushing from the center outward, working out any creases or bubbles. Keep the weave square or it will be very distracting when painting.

4 Turn the board and fabric over and trim across the corners, not cutting it too short as the size will shrink the material, nor leaving it too long as it will be lumpy in the frame.

5 Size a margin around the edge of the reverse of the board wide enough to stick down the overlapped cloth, which should not be pulled too tight as it encourages the board to warp.

6 Smooth down the flaps of material and fold the corners over neatly. Turn the board over, brush off any dust, and dry flat. Add a final coat and dry overnight before priming.

Primers

The white ground or primer has three functions: to act as a long-lasting, flexible bond between support and paint; to compensate by its whiteness for the ultimate darkening and translucency of the paint with age; and to create a responsive painting surface.

Over the centuries there have been many recipes for grounds, each claiming their own identity and 'feel' (see opposite) and varying in absorbency and tooth. Absorbency is controlled by the amount of size in the ground, and you will need to find out from experience how strongly this affects the way the paint behaves and which primer best suits how you want to paint. On a non-absorbent ground the paint remains fluid and can be pushed around which is useful for the less experienced or leisurely painter. On a more absorbent surface the paint becomes mat and dry almost immediately, giving a flat, chalky quality.

The simplest ground on canvas consists of two coats of size and a thin coat of housepainter's mat white oil undercoat. You can also lay a ready-made primer on to a board without sizing. The egg emulsion below is suitable for boards or canvas.

Mixing an emulsion primer

This is the most versatile, reliable, whitest and longest-lasting painting surface. For a more absorbent ground, lay two coats; for less absorbency, apply up to four coats, sanded between each one. Ingredients: 1lb titanium white powder, a 2oz (medium) egg, refined linseed oil and size. As a guide, this amount will cover two 20×24in supports with three coats.

1 Break the egg into a jar with a tightly fitting screw top. Crack the shell evenly in half, as this is your measure.

2 Fill each half eggshell with cold water twice, and shake it up with the egg. Add each half eggshell filled once with the linseed oil.

3 Shake hard for five minutes to emulsify. Stand the jar of size in a pan of warm water and dissolve it over a gentle heat.

4 Place a third of the powder on a large plate, and make a well in the center. Dribble in the emulsion, blending with a palette knife.

5 Smooth out all the lumps, slowly adding the emulsion until the mixture resembles thick cream cheese. Tip this into a bowl.

6 Add lukewarm size by degrees, stirring until it looks like thin cream. You can adjust the amount of size for the required absorbency.

Laying the primer

With a household paintbrush, begin at the edge, brushing quickly, evenly and thoroughly in all directions. While this dries (about an hour) the unused primer will solidify. Warm it again for the next coat and if too thick, add a little water. Lightly sand after each coat, applying three in all, drying flat in a clean place. Wash the brush in lukewarm water. Although the canvas can be painted on next day, it is much nicer if matured for six months.

Other types of primer

Gesso: for panels only	Traditionally gesso was a primer for tempera, gouache and oil, made up of size and slaked plaster of Paris, not size and whiting as it is today; the term is not now strictly accurate. It is a simple, reliable, chalky surface with no flexibility as it contains no oil so it is suitable only for boards. At least two coats are needed. If you find this ground too absorbent, add a final coat of size. It can be painted on next day. Unlike the egg emulsion, it does not improve with age.
Gesso with oil: for panels and canvas	Adding some linseed oil to the size and whiting recipe produces a slightly yellow ground which is flexible enough to be used on either board or canvas.
Acrylic primer: a modern equivalent for wood or canvas supports	Bought ready-made, it must never be used over a sized support as it will crack badly. Apply one or two coats direct to the panel or canvas, the first one diluted with water by half the amount of the primer. Sand in between each coat with fine sandpaper. The surface can feel 'plastic' and durability is still to be proved.
Quality oil undercoat: a mat-drying, oil-based primer	Available from the hardware store, or as a prepared oil primer from art suppliers. Will yellow 'in time'.

Brushes

Brushes should represent a painter's major investment. When painting, each new color demands a clean brush, and only good brushes will help to put the paint in the right place. However, they are not the sole tools for applying paint: fingers can blend edges and a painting knife lay in thick color.

The best brushes for oils are the stiff-bristled hogshair and the soft-haired sable but many materials are used.

Bristle brushes

The best bristle brushes are made from bleached hogs' hair and increase in size from 1 to 12. (Extra large sizes extend up to No. 36.) The beginner should start off with sizes 2, 3, 5, and 6 in 1, the round or 4, 5 filbert shape. Flats 2 and brights 3 can make monotonous brush marks. Choose short or medium length bristles; long bristles can be hard to control. Top quality sables come from the Russian kolinsky. They are for finely detailed work but can encourage fussy paint in the hands of the inexperienced.

Sables

Worn brushes

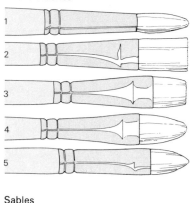

A new brush will need several hours of use before it is 'broken in'. It should then wear evenly all round, keeping its shape, with no stray hairs.

Makes vary in size, the amount of bristles, and wearing qualities. Expensive sables can last 20 years while cheap synthetics may survive for only a few painting hours. Lazy cleaning, harsh painting surfaces and messy painting habits will destroy any brush within a matter of days.

see also pages 30,
42–45

Other useful brushes

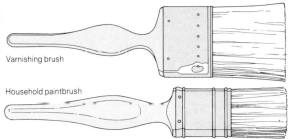

Varnishing brush

Household paintbrush

Some painters prefer a selection of bristle brushes and sables, others settle for one type and size, but everyone needs a brush for varnish and one for grounds.

Cleaning brushes

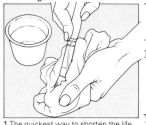

1 The quickest way to shorten the life of a brush is to leave it dirty after use and then have to resort to paint remover to clean it

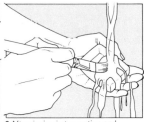

2 After rinsing in turpentine and wiping thoroughly on the rag, soap the bristles well with plenty of pure household soap and warm water.

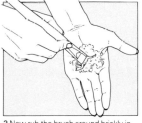

3 Now rub the brush around briskly in your palm, rinsing now and then, making sure that all the paint is out, especially around the ferrule.

4 Rinse the brush under warm running water, shake it out and smooth it into shape. (Don't get into the habit of licking brushes.)

Drying brushes

Brushes cannot be used again until dry. They may be wrapped tightly in waxed paper, or smooth the bristles over with slightly soapy fingers. If used often, leave in a jar, bristles up. Otherwise store flat (p136).

Paints and mediums

All paints vary in texture, opacity, translucency and in degree of color and adhesive permanence, depending on the chemical property of the dry pigment and the amount of oil required to absorb that pigment and convert it to a paste. White, and the earth colors such as the ochers, umbers and siennas, are generally thicker in texture and greater in opacity than the darker paints like alizarin, ultramarine and black, which tend to be thin and quite translucent. It is these qualities that determine how and when they are applied to the support.

Brand name oil paints are generally produced in artists' or students' (budget range) qualities, the first being made in an extensive range of pigments, irrespective of cost; the second representing a narrower selection of tints from the cheaper, chemically based dyes, hence light fastness is not as good. It is a time-worn cliché, but true nevertheless, that you get what you pay for. Do not economize here; buy the best.

Warning: Almost all pigments can be hazardous to some degree, particularly if left within the range of children. Flake (lead) white is dangerous and should not be allowed to get into a cut, abrasion or under the fingernails. Take sensible precautions and wash your hands after painting.

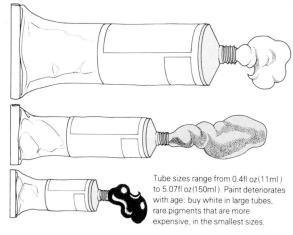

Tube sizes range from 0.4fl oz(11ml) to 5.07fl oz(150ml). Paint deteriorates with age: buy white in large tubes, rare pigments that are more expensive, in the smallest sizes.

Removing excess oil from paint

Some colors contain more oil than others, and although this excessive oiliness can be blended with the paint when it is on the palette, it is sometimes more than you want to have to work with on the canvas. Squeeze some pigment on to a thickness of newspaper and leave it for a time. Some surplus oil will then be absorbed. This was often practiced by artists such as Degas and Toulouse-Lautrec.

see also pages 48,
124, 131

Caring for your paints

Colors tend to solidify in
the tube if left
uncapped. Put the cap
back the moment you
have used the paint;
make sure the threads
on cap and neck remain
clean. A palette knife
held at an oblique angle
and scraped along a
finished tube will
remove the last scraps
of paint.

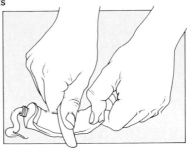

Stuck caps

If pliers do not work, hot water often
will. Failing this, hold a match under
the cap for ten seconds, or grip the
cap between a door and the jamb,
then twist off.

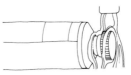

Mediums

There are many oils, diluents and varnishes that, when combined with the
pigment straight from the tube, can be used to change its consistency: its
'feel', its 'fatness', plasticity and drying speed, so that the paint can be termed
'short', 'long' or even 'buttery'. Oil binds the raw pigment; adding more oil or
more diluent alters its structure, character and handling, and ultimately the
quality of the paint on the canvas. Finding which mixture suits your style or
creates the effect you want to achieve can only be accomplished by trial and
error. You may want to try using no medium at all; it is by no means mandatory.

After underpainting with paint and pure turpentine only, you could start with
a medium of 15% refined linseed oil and 85% turp. As the painting builds, add
an increasingly greater proportion of oil, but never more than one third oil to
two thirds turp. This is called painting 'fat over lean', a sound old principle (p74).
Experiment with mediums with varying drying speeds or viscosity and keep a
record of the results in a notebook. Once you have found a medium that suits
you mix up a large quantity in a jar.

Keep the medium in the palette cup clean and change it if necessary. Don't
rinse your brush in it as it will make subsequent mixtures muddy and dingy
Colors should stay clear and bright.

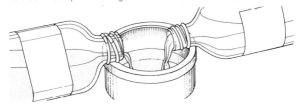

Refined linseed oil is a popular medium in combination with genuine turp
(spirits of turpentine), with average drying speed and minimal yellowing.
Linseed-based stand oil and sun-thickened oil mixed with turp are also quite
common (p131). Genuine turp will evaporate and thicken unless kept closed
and away from light. Use it for thinning down paint; rinse brushes in regular
turpentine.

Palettes

The palette's shape will probably be dictated by whether you stand or sit to paint, work out of doors or inside. You do not have to hold the palette. It can rest on your knees or be positioned beside you on a small table (an old tea cart is ideal), in which case the palette can be a piece of smooth wood or glass. An oval or studio shape (1) is well-balanced for standing at an easel, while rectangular palettes (2) fit in a painting box and are practical for painting in the field. Paper palettes (3) come in tear-off pads, each sheet being used once and then thrown away. These cockle disconcertingly under the color mixtures and tend to flap about when used outside.

The palette should be as large as you can manage. It has to accommodate the blobs of pigment around the edge and, in the middle, mixtures generous enough to be able to complete a large area of the painting, without all becoming intermingled. The paints should not be dotted about haphazardly but reflect a sense of order and harmony.

Knives

Painting and palette knives come in many shapes and sizes. **Palette knives** (top) are for drawing colors together, for losing an edge, for scraping off the paint (see p45). Some people use them for mixing paints on the palette, others favor brushes. They are handy for cleaning the mixtures off the palette at the end of the day and for transferring unused blobs of paint to an airtight can. You can also apply paint with them, although cranked-handled **painting knives** in trowel, pear and diamond shapes are specifically designed for this purpose.

Palette cups

Palette cups clip on to the palette in the most convenient position. One holds medium, the other turpentine for rinsing brushes, but most painters who stand at the easel keep a glass jar or tin can on the painting table. If painting fluidly and using a lot of medium, or outside, or on holiday, pre-mix the medium and pour a small amount into the palette cup. Buy single palette cups; with double ones you cannot pour back the medium.

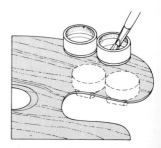

Making your own palette

Scale up the drawing on brown paper to make a template (one unit equals
1¼in), or make one from a friend's palette, after trying it for size. A lumber yard
will cut the pattern out of 3 ply marine plywood. Make sure that the best side
will be uppermost. Sandpaper the edges, beveling the thumbhole on the
leading edge on top and the back edge underneath. (Reverse for a left-handed
palette.) Having adjusted the balance (below), season the wood several times
with linseed oil overnight (this also applies to a bought one). The cost? About
half those sold in the shops, and enough wood left over to make a rectangular
one too.

Cleaning the palette

At the end of each painting session, scrape off the mixtures with a knife on to
newspaper and wipe the palette with paper towels. If resuming in a day or two,
the squeezes of pigment remaining can be covered with foil or a hard skin will
soon make the paint lumpy. If not painting again for some time, these must be
removed too. Now rub any oil/turp medium left in the palette cup over the
palette with paper towel or rag until clean – a wonderful patina will form in time.
Turpentine can be used but is less beneficial alone and should be followed with
a film of linseed oil.

Holding the palette

Hold the palette in the left hand (if
right-handed), resting it on the
forearm and fitting it up against your
body. The beveled edge of the
thumbhole will be on the right side
on top and on the left side (toward
your left elbow) underneath. You
may need to sand it to fit your hand.
Can you hold the brushes
comfortably in your hand, not in your
fingertips? Check the balance of the
palette by weighing it on your arm. A
block of wood or lead weights can
be fastened underneath; any
imbalance will tire your arm.

Easels

There are two kinds: the sturdy studio H-type or the three-legged, folding radial easel for indoors, and the light folding types for outside or inside use. The traditional adjustable studio easel on wheels (1) is expensive and cumbersome but ideal for very large canvases. It operates on a similar system to its counterpart, the popular, more compact radial easel (facing page). Folding or sketching easels (2) are necessary for most landscape painting. They should be simple to erect and adjustable to a comfortable height if you stand to paint. The tripod legs are often spiked and can be pushed into soft ground. Improvised painting boxes can range from tool boxes to tackle boxes. The practical box easel (3) combines paintbox and easel in one compact unit. The tilt board or table easel (4) with adjustable height and rake supports the canvas for indoor subjects (and so will a table and chair).

1 The robust studio easel. 2 The sketching easel. Wooden ones warp and swell, metal ones bend and dent. Telescopic ones cease to telescope. Try them before you buy them. 3 The box easel has a palette, drawer for paints, tilting easel and canvas carrier. 4 The table easel.

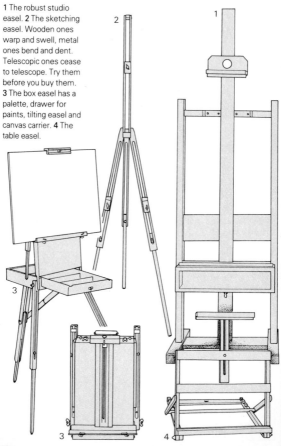

Adjusting a radial easel

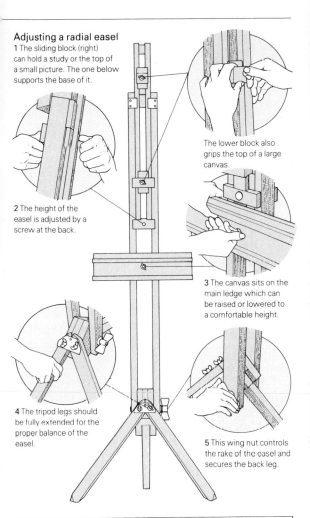

1 The sliding block (right) can hold a study or the top of a small picture. The one below supports the base of it.

The lower block also grips the top of a large canvas.

2 The height of the easel is adjusted by a screw at the back.

3 The canvas sits on the main ledge which can be raised or lowered to a comfortable height.

4 The tripod legs should be fully extended for the proper balance of the easel.

5 This wing nut controls the rake of the easel and secures the back leg.

Easel extras

Brackets can be bought, or made at home, which slot into the easel uprights for the palette to be rested on. A single bracket to the side could hold the tin can of turpentine for rinsing brushes. Sometimes it is necessary to nail a length of molding to the ledge on which to sit very small panels so that they do not fall off. A heavier piece of wood extending to each side can support an extra large canvas. A square of composition board hung within view is essential for pinning up notes and reference material. A table-top folding music stand at your elbow is convenient for propping up sketches when sitting to paint.

The work area

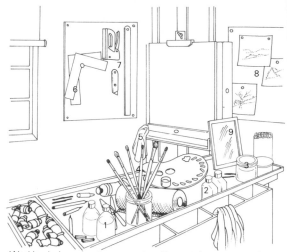

Working indoors has two aspects, either setting up an easel painting, usually for an arranged subject, such as wild flowers in a vase, or a portrait, or it could be a found subject, something which you come across by accident that excites you. It could be the decorative remains of a meal which must be painted right away, calling for the mobility of a paint box.

The basic materials you will need in your workroom include refined turp and linseed oil (1, 2) or your choice of another medium, regular turp (3) in a glass jar or tin can for rinsing brushes, a selection of bristle brushes and a sable (4), cotton rags (5), card cut-outs for framing up the subject (6), stretching and framing tools (7), sketches (8), and a mirror (9) to check your composition.

When painting outside, you might sit on a folding stool with the painting box in your lap, or in the open back of a car with a rear door; the picture is propped up or slotted into grooves in the lid. For supports larger than the lid of the box you will need an easel. Sketching easels are never very stable. The tripod legs will be more secure if wedged with rocks, or a plastic bag filled with stones can be suspended from the central axis of the easel.

The palette box
A large pocket-sized painting box which will hold a handful of paints, a bottle of pre-mixed medium, palette cup, palette and two panels, and is ideal for spontaneous sketches.

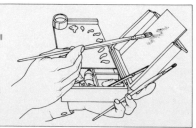

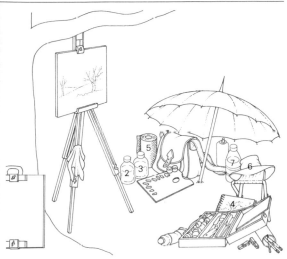

Your equipment should include several bristle brushes (1) so that you do not have to keep washing one or two brushes; pre-mixed medium (2); turp (3); a drawing book (4); pen, waterproof ink and distilled water, a brush or watercolor pans and some clear water to make tonal drawings. Paper towels (5) and J-cloths are useful for mopping up. Also include some protection from insects and the weather, such as a brimmed hat (6), and water (7) and soap for washing your hands at the end of the day.

Making a brush holder

Cut four slots in a piece of stiff cardboard and secure brushes with rubber bands.

The paint box

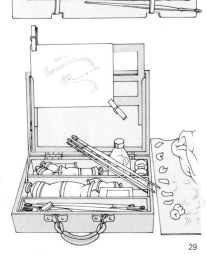

Sketchboxes or paint boxes with palettes, available at good art suppliers either empty or equipped, are a very real substitute for an easel if working on small canvases or boards which can be completed in one sitting. The panel is clipped to the lid with clothes pegs or bulldog clips. A box takes very little time to set up and affords the painter greater mobility and flexibility.

Preparing to paint

Learning to find a rhythm when painting is a good habit to foster and one which is made much easier if you organize yourself, your equipment and your work area, whether it be inside or out.

First, consider your own comfort. Do wear practical clothes that do not need to be protected from the inevitable splashes and smears, and those loose enough that they do not restrict your arm movements. Wear shoes in which you can stand for longish periods. Practice standing with your legs spaced a little apart, or sit upright without tension, shoulders relaxed. You should be at a convenient height in relation to the subject you are painting, the easel and the support. Is there sufficient ventilation or heat in your workroom? If working outside, are you protected from intense sunlight or a cold wind? Is your equipment within easy reach? Put out all your paints on the palette before you start and avoid looking for them later or making do with the ones you have laid out. Position the jar of turpentine for rinsing your brushes where it cannot be kicked or knocked over.

Some people are inspired to paint by something they see, others by an idea. It would be a tragedy if this initial stimulation were lost in the practical considerations of getting set up, and if the pure delight of simply picking up a brush whenever and wherever something moves you were to be ignored.

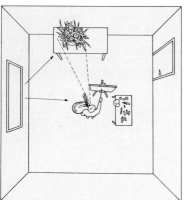

Setting up indoors
The light should come from over the left shoulder if you are right-handed, and vice versa. Decide whether you will paint in natural or artificial light. Stand or sit where you can see both subject and canvas at the same time without peering around the easel or over the lid of the painting box, and do make room for stepping back regularly to assess your picture without tripping over your equipment.

How to hold a brush
Hold the brush where it feels naturally balanced but not too near the ferrule. This limits movement to the fingers and encourages brush marks that will be monotonous and restrictive. Put an elastic band or tape around the brush – it will serve as a reminder each time your hand slips down toward the bristles.

The right attitude

Even if you can't paint well, *look* as though you can! Think of the brush as an extension of yourself. Don't restrict your arm movement and gestures if painting on a large canvas, nor get too close to your work that you stab at it. The movement of the arm from the shoulder, through the elbow and wrist, should be fluid, confident and controlled. Find out just what the brush can do.

The rhythm of painting

This is not a haphazard thing. Like serving at tennis or changing gears in a car, any rhythm takes a lot of practice. Sometimes, in spite of appearing to do everything right, co-ordination is lacking.

First, look intently at the subject and the canvas, remember what you see, mix the colors on the palette, apply the paint, wipe your brush on the rag over your arm or knee, or rinse it in the turpentine, then look at the subject again. It is important to place yourself so that you are able to see what you are painting as well as the canvas with minimal movement. The memory cannot accurately retain an image for more than a few seconds. If you turn your head away for much longer than this, it is easy to invent what you think you see, rather than interpret it.

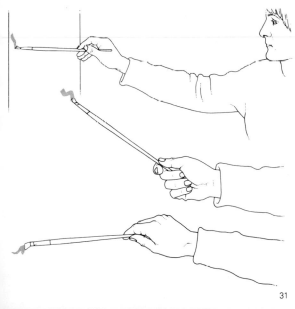

Techniques

These sequences show the development of a still life, a portrait, a landscape and a seascape from the bare linear construction to the fully worked tonal painting.

It is important for painters to develop an individual style. Visual awareness and sensitivity are much more valuable than technical skill. A great body of practical knowledge has been passed down from earlier painters who had to develop the techniques of oil painting by trial and error. While you can learn from them and use their methods, you must remember that it is not just dexterity with paint and brush that gives their work its enduring appeal. Many lesser painters have had superb skills – what they lack is the ability to inspire.

Over the following pages there are many practical hints and full descriptions of the processes you should use to paint cats or flowers, seas or reflections. Remember that these can only go so far. Each person brings a little of himself to a painting, and to be an accomplished painter requires you to be able to see and express what you see in an individual way.

The approaches to painting

In general there are two broad categories of contemporary painting, separate in concept yet at times influencing the other. In the first, the perceptual painter is concerned with representing the real world; in the second, the conceptual artist uses the real world to reinforce his original imaginative idea.

The following paintings, whether painstakingly built up in many layers of paint or spontaneously executed, represent a link between the old and the new in the way artists see, look and think about painting.

Painting from direct observation

The majority of painters rely for inspiration on the confines of the rooms or landscape they live in and few have been better than Edouard Vuillard at extracting from the ordinary world such a wealth of extraordinary images. Any figure, object or vase of flowers set against a backdrop of a room, window or landscape became an absorbing subject.

A humble fireplace inspired *La Cheminée*. The broad planes of the mantelpiece dominate the center of the picture, forming the basis of the unique and daring composition that is the strongest feature of this intimate painting.

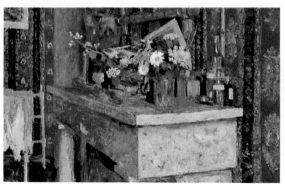

Following Vuillard's example, look for viewpoints other than those that are most obvious. The mantelpiece, for example, is viewed from a steep angle and recedes dramatically into the picture, its movement halted by the clothes-horse at the left. This sets up a strong geometrical pattern with the horizontal stripes of the wallpaper, relieved by the charming, star-shaped mass of the wild flowers. Use compositional structure in this way to heighten the visual impact of your work.

Strong horizontals and verticals can be satisfying, or monotonous. Make a preliminary drawing noting down nothing more than the vertical divisions so that you are aware of their spacing and can disguise a too obvious geometry.

Painting composed from studies

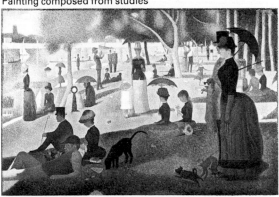

A wealth of imagery makes Georges Seurat's *Sunday Afternoon on the Island of the Grande Jatte* a feat of majestic organizational power. His idea of people relaxing, stretched in frieze-like order across a corner of river-enclosed island was conceptual, but ideas are stimulated by acuteness of perception and realized by means of images drawn from observation.

To turn an idea into a pictorial image does not necessarily require the innumerable separate studies that Seurat created when assembling the *Grande Jatte*. The two drawings that influenced the final work more than any other contain all that is needed for its composition, geometry, rhythm and tonal order. The stage is set in the preliminary drawing, below.

The key to the picture is the forked tree. Its diagonal limb touches the top of the canvas above the white square under which Seurat has placed the black dog. In the painting he uses it to locate the child. Dog, tug and sailboat are already in position for the final painting.

Pointillism

Seurat used a form of stippling in which dots and dabs of primary colors are laid side by side on the canvas and mixed optically rather than on the palette. 'Isolated on the canvas, these colors recompose on the retina: what we have is not, therefore, a mingling of colors conceived in terms of pigment. It is a mingling of colors conceived in terms of light.' (1886)

In the drawing *Couple Walking* it is the forked tree whose arms, light against dark, appear to conjure two forms, dark against light, from the shadowed ground beneath. The two figures drawn as one form sit at the junction of the horizontal and diagonal movement of the large foreground shadow, and join the lower shadow to the dark foliage above. They are a silhouette of great beauty, their two hats partially divided by a flower and the woman's bustle echoing the parasol.

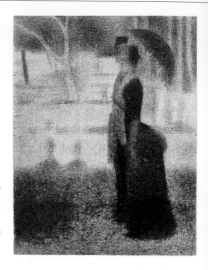

Echoes

Notice how forms stand side by side, merge into one, tonally counterpoint or complement each other in the painting (previous page). Sometimes these pairings are obvious, often they are complex. Look at the woman with the red parasol dividing the two trees in the finished picture. She stands at the center of the composition and with a subtle touch of humor marks its two halves by the inverted V of her jacket echoing the forked tree. By using such devices, you can link the scattered elements of a complex composition.

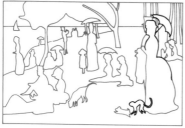

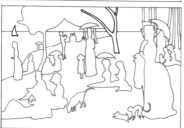

For an artist such as Seurat, the structure of a picture was of paramount importance. Examining the *Grande Jatte* reveals a host of unifying echoes. The white wall across the river, the stable horizontal of the eye level, connects the white yacht to the forked tree. The triangular branching of the tree echoes its inverted shape in the two-sailed yacht. The elegant curve of the parasol held by the standing woman on the right of the picture is echoed in her bustle, and the loop of its handle by the monkey's tail.

Painting from a drawing

It is no accident that the easel picture over the centuries has been 'worked up' in the studio away from the subject that was its inspiration. One reason is that it can simplify the artist's task by eliminating some of the conflicting evidence and overwhelming sensations out of step with the underlying idea.

All the information Walter Richard Sickert needed to create a masterpiece such as *Ennui* was to make a drawing of the scene, noting the distribution of tone and shape with added color notes, if required. His masterly observation, for instance in the size of the glass in relation to the man's head and the decanter, sets the remarkably true scale of the picture. Color harmony to Sickert was set on the palette, firmly controlled by the mind, not the scene where light fluctuated disconcertingly moment by moment. His mentor Whistler had said, 'I mix my colors with my brains'.

At the beginning of the drawing the important thing was to set the scale, noting the relationship of one thing to another. Sickert would have posed his figures carefully, especially fascinated by the difference in size when one figure in the middle ground crossed another in the background. By placing the figures to link up with the furniture he was able to connect them to the picture plane. Notice the line of the woman's elbow, how the division in the top drawer accentuates it, and the shadowed edge of the table completes it. Similarly, the left-hand edge of the picture frame is parallel to a line through the woman's hair and the man's hand.

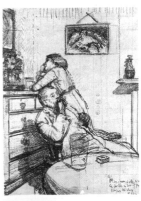

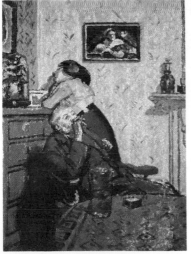

The drawing has been squared up and transferred to the canvas. The tonal arrangement in the painting is simple: a large dark area is locked into the left-hand side by the positive light shape of wall and table. All the tonal divisions are noted except the man's coat, the woman's skirt and the chest. Sickert's intention to create an interesting division of shapes is given a subtle twist by the subject, the united figures separated by their boredom. Pictorial structure is thus combined with the work's message.

The sketch

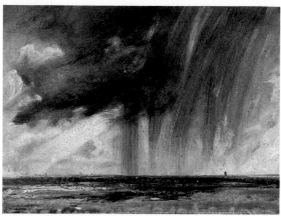

John Constable was a painter in pursuit of the moving rather than the static qualities of nature. For an artist to achieve on a small canvas the monumental effect of nature requires an understanding of scale. In *Seascape with Rain Clouds* the sky is given its vastness by the low horizon and the scale is set by the small but insistent dot representing a sailing ship. There is also a lighter, complementary dot balancing the left-hand sea line. The mood is created, not by careful imitation of nature's many shapes – an impossibility on a day such as this – but by many quick and different hand movements, equivalents for sea and clouds, wind and rain, light and shadow.

The marks of the brush

The contrasts of tone, the light and dark cloud masses, the interplay of opaque and translucent color on the crests and troughs of the waves, and strokes from various widths of brush heighten the drama. The direction and force of the wind is implied by the flurry of dark diagonal strokes that move right to left across the simpler brushstrokes of the rain squall.

Toned grounds

A toned ground is laid over the primer with pigment mixed with turpentine, which evaporates quickly, and applied with a large brush or a rag. Successive layers of paint should be increasingly 'fat' or they may sink in later, looking dry, dull and mat. The key to the speed necessary for Constable's sketch is undoubtedly the warm, mid-tone translucent ground laid evenly over the surface, then left to dry fully. A series of cool complementary blue and green grays with warm whites and dark grays was then swiftly applied over the ground.

Dramatic vigor is given to the whole painting (opposite) by the shaft of diagonal light that perfectly divides the right angle of distant view. Though short and sharp, it is given grandeur by its implied length joining, as it would do, the top right corner of the painting to the strong left-hand sea line. For maximum emphasis Constable has set the dark squall of rain upright, cunningly disguising his intention by the dextrous flick of dark pigment on a dry brush at the point of intersection. The firm dark horizontal of the sea completes the emphatic right angle which in turn helps to spring the arching movements of the dramatic cloud shapes. Constable, undoubtedly, had no rival in the portrayal of nature's transient moods.

Abstract painting

Josef Albers experimented with the visual phenomena of closely related colors. Through a simple format of squares within squares he explored the relationship of color and geometry and how visual perception and optical illusion override a linear discipline, a concept which later influenced Op Art.

For an artist such as Albers, the effect of colors viewed together was the main subject for painting. *Homage to the Square: Departing in Yellow* uses variations in the tones of yellow squares to create an impression of receding and advancing space. Color can have an independent energy and manipulate the mood of the viewer.

Study the picture and let your eyes become saturated with the color. Notice how the flat picture plane seems to become three dimensional, the strips of color appearing to float off it, one color advancing, another receding. Each square reacts to its neighbor, shifting in character as the light changes. Remember that colors can affect each other in these ways.

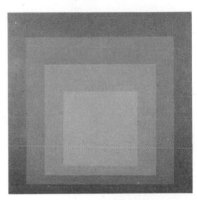

Hard edges

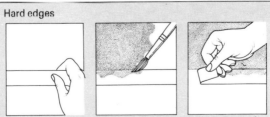

Many abstract paintings rely for their effect on the interaction of areas of color within geometric forms. A hard or straight edge can be painted freehand or with the aid of masking tape. Lay the tape along the line you wish to draw keeping it straight and flat, paint generously up to and over the edge of the tape without going too far, then carefully peel away the tape.

Abstract painting based on reality

There are many reasons why an artist paints an abstract picture. In this case Victor Pasmore has translated a visual stimulation into its abstract equivalent. There are times when, in trying to capture the scene as it meets the eye, a painter loses sight of the inspiration for the idea. In *Beach in Cornwall* (bottom) both emotion and intellect are kindled in the artist to express his idea in abstract terms while at the same time successfully describing the reality of the scene before him.

The forms caused by erosion and wind movement intrigued Pasmore. The spiraling *Snowstorm* (right), eddies of water, all the conscious patterns of the elements were interpreted in abstract terms. When the figurative elements had been pared away only the spiral motif remained.

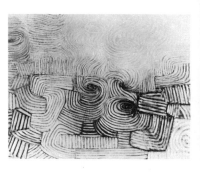

Resistant rock meets the moving force of water and both are linked by their shapes to a pattern of cloud-filled sky. The ebb and flow of the tide blends with the once liquid movements of the rocky sea bed. It is only the strength, rhythm and sensitivity of line creating the jigsaw pieces that enable the viewer to identify the organic elements in *Beach in Cornwall* below.

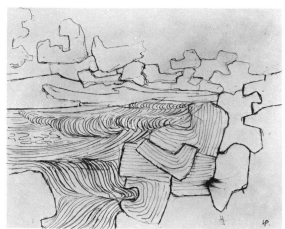

Painting from the imagination

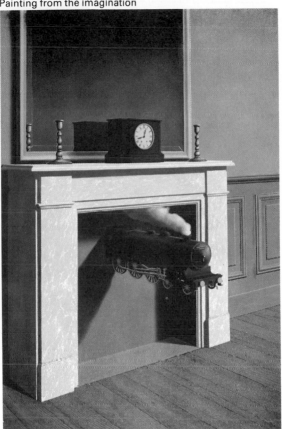

Great artists can instil such conviction in the observer that the image created is
rarely questioned as being other than a faithful representation of the scene.
René Magritte pointed out that an image is only the symbol or visual language
for what it represents. Once the realization is fixed in the mind of the viewer
that the image is not what it pretends to be, the artist is free to conjure with it
at will. He can move images out of time and place and juxtapose meaning.

In *Time Transfixed* the engine moves illogically from the fireplace into the
room but as logically emerges from a tunnel with its smoke being drawn up the
chimney made for that purpose. The back of the clock, reflected in the mirror,
offers no opening, no mechanism to trace time moving, nor does the mirror
give a clue to the source of light. The shadows that fix the time of day are
stilled, the hands of the clock stopped and the engine motionless.

Magritte offers an impossible moment when an engine leaves its rails and
enters an empty but expectant room. The illogical and the rational co-exist. The
tunnel is sealed but the chimney is open. If the rails could be found, would this
absurd moment be reality?

Brush marks

There are no special 'marks' to learn for trees, or sky, or water. Any kind of stroke or method of putting on the paint is acceptable. You will feel how the brush responds quite differently on canvas compared to board. Canvas feels springy. Board covered with fabric is solid by comparison. The paint remains on the top and can be built up to look thick and rich.

Each shape of brush is capable of making several marks: you can use only the tip, or press quite hard, or use a dry brush technique. Aim for variety.

Building up with small touches

This style of painting takes time and patience. With a filbert brush start with the darker or middle-toned elements. Each mark, however small, should have a definite shape rather than being purely a mechanical touch. Mix the colors on the palette rather than on the painting or you will end up with a sticky mess. With this method it is not so vital that you build up the picture from dark to light as, on such a small scale, the darker colors will sit quite happily on top of the thicker, lighter ones.

Thick paint laid in with a brush

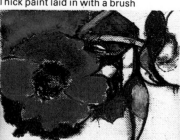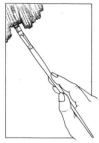

You will soon discover that all pigments have different properties: opaque, translucent, thin or thick. Whites, Naples yellow, the paler earth colors and mixtures containing white tend to be thicker in consistency; darker colors look more luminous if kept thin. Consider early on what elements you wish to emphasize as the thicker areas of paint usually dominate the composition. If you paint a picture in one layer, *alla prima* style (most landscapes are done this way), then keep to simple brush strokes for speed.

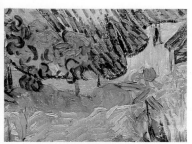

Vincent van Gogh
Farms near Auvers
The rhythms set up by the swirling lines suggest an energy generated as much by van Gogh's own passion as by the subject. With a loaded brush he built up the surface in single strokes of similar length and brush size.

Applying thin paint

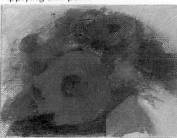

One of the delights of oil paint is that it has substance, unlike watercolor, which can be manipulated in numerous ways. When paint on a finished picture is too skimpy overall, both this 'body' and the glorious richness of the color is neglected. However, in the initial stages, the general rule is that the larger the area covered the thinner should be the paint. Scrub these in with a large brush. Then you can work progressively from thin to thick, 'lean to fat' paint (p74), aiming for variety and balance across the canvas.

Bold, angled strokes

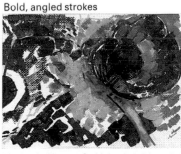

Like handwriting, van Gogh's brush mark has a distinctive style, yet it is much more than just handwriting. Each stroke in his painting (above) was considered and thought out and is charged with controlled energy and liveliness. Cézanne also, in the last ten years of his work, made much use of strokes lying in similar directions so that by means of the angle of the mark he could describe the textured planes of a building or the form of a tree. These marks are not for the timid and should be made with a sense of conviction.

Light and dark paint

Dark colors and black should be applied thinly to achieve an effect for depth and richness. Conversely, white and pale colors appear lighter as their thickness and opacity is built up on the canvas.

Scumbling

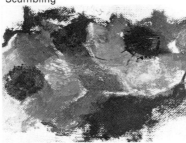

A scumble is a light, opaque paint that is laid vigorously over a darker, thin color that is already dry, producing an interesting effect of strong light and shade with a textured surface. The scumble is usually applied fairly dry in a dabbing, smudging, stippling or circular movement, or dragged across the surface to break over the existing layer of paint, creating highlights. Instead of thick, even paint over the whole picture, the result is glowing dark passages over the light ground, in contrast with the light, broken paint on top, allowing some of the darker lower layer to show through.

Impasto

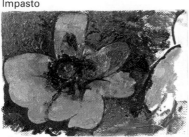

Often used to give a picture a three-dimensional quality, impasto is thick paint applied generously to the canvas with either a brush or a palette knife. If alternated with thin touches, it gives the surface vitality and variety. Paint and medium (stand oil is good) are mixed together on the palette and applied to the canvas. Shape the paint with the knife. If working with a brush, have it fully loaded, remembering that the marks the brush makes will contribute a dominant textural quality to the painting.

Painting knife

At this stage do not worry too much about how the marks are going down on the canvas but experiment with everything in every way – paint can be scrubbed in rapidly with a brush or painstakingly built up in small touches. The edge of an object can be carefully delineated or large areas of paint laid down with a knife. Choose a knife that is very flexible. The look of the paint will remain fresh and attractive if you put it down decisively, otherwise it could become mannered in appearance.

Building up stains

Rather than applying opaque layers of paint, many artists use a palette knife to push the paint into the weave of the canvas, building up a series of blended images composed of translucent stains and resulting in beautiful colors. The paint is applied to the canvas, then scraped down with the knife. As it becomes semi-dry, another layer is added.

The absorbency of the surface

The texture of the surface and the type of ground you use will affect the marks you make. A non-absorbent ground is needed if you want a rich build-up of paint. If painting in thin layers, or stains, you will need a moderately absorbent ground. The absorption can be varied by altering the proportion of glue size or acrylic to the gesso. More size makes a less absorbent and harder surface; less size gives greater absorbency. Acrylic grounds become more absorbent when diluted with water.

absorbent ground

non-absorbent ground

Color wheel and tonal scale

Sunlight is composed of the colors of the spectrum seen when the different wavelengths of light are separated by a prism. The degree to which something either absorbs or reflects varying light frequencies is what gives it a particular coloring. Practically all the light we see is reflected and the behavior of colored light, when mixed together, is quite unlike paint.

Tone refers to how light or dark something is, or looks. In nature the range of tones stretches by infinite degrees from bright sunlight to the blackest shadows, which a painter can only generalize in paint on a very limited scale from white to black.

The color wheel is simply the spectrum with its ends joined. In general colors adjacent to each other produce the purest mixtures while those opposite make browns and grays.

The color wheel

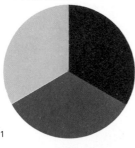

1

2

3

1 The colors yellow, red and blue are called the primary colors because all other colors can be derived from them. 2 Orange, violet and green, because they are derived from the mixture of two primaries, are called the secondary colors. 3 The third wheel shows in more detail some of the intermediate colors occurring as a primary moves through a secondary to another primary, producing tertiary colors, for example blue-greens, pinks and mauves.

Tonal value of color

The color wheel of primaries and secondaries shows their equivalent tonal values. Judging the tonal value of things which are themselves colored requires some practice. Backlighting will lower the tone of an object considerably even if it is light in color, whereas a darker colored object in the distance may actually appear lighter in tone than a comparatively pale object in the foreground. This is more apparent when seen through half-closed eyes.

The tonal scale

It is estimated that if the tones around us are represented on a scale of 1 to 100, pigment can only record about 40 of these. You can try taking a color (or black) and adding white progressively, keeping the jumps between each tone absolutely even. Establish the mid-tone, then tones between white, mid-tone and black.

Now fill in the rest of the scale, aiming for at least 15, adjusting each one to make a smooth series of gradations. Those paintings that take their relative tones from the light end of the scale are said to be in a high key, those from the dark end in a low key. Note the greater tonal variety at the light end of the scale.

Complementary colors

The colors that lie opposite each other on any color wheel, however complex, are called complementary colors. Every color has one and you can find it without referring to the wheel by staring fixedly at a color for about 30 seconds, then looking at a piece of white paper. The after-image that appears will be the complementary color. A touch of its complementary in a color will modify its intensity. A hint of its complementary next to an area of color of the same tonal value will excite it to its maximum vividness, yet a color mixed with its complementary will be reduced to a brown or gray (above). This is a useful way of mixing these neutrals without adding the muddier earth colors. Compare the limited range of grays that can be made from black and white (top) with the richer and more interesting grays mixed from the complementaries of similar tonal values. Add degrees of white to increase the range.

Setting the palette

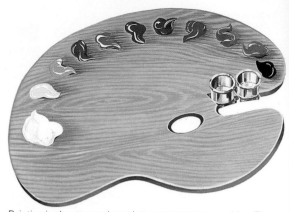

Painting is about arranging colors to represent something. The range of pigments that come in a tube is so limited compared to the range of colors in life that artists can only make equivalents. The colors of the spectrum are transparent and colors formed by light can never be duplicated by an opaque pigment.

A painting is built on the palette, with each color separated from but related to its neighbor. A palette should be like an orchestra tuning up – many voices different and distinctive but all with a purpose. There are several systems for laying out colors but you should find one with which you are comfortable and stick to it. You may have already worked out an arrangement you like. Some painters separate the warm colors from the cool colors with a large squeeze of white in the center at the top, or you could have two blobs of white, one at each end of the other colors. On the palette above, the pigments have been set out in a generally light to dark, warm to cool sequence. A large squeeze of white is placed on the extreme left, working across from yellow to the reds and earths, and at the center the raw umber that divides the warm and cool colors, finishing with the black on the right. The inclusion of black has often been frowned upon, although every great painter has had it on his palette.

Selecting your palette

All pigments can now be mixed together. Until recently emerald and the chrome colors were not compatible with black and turned a dirty color in time. Today almost any color you need can be mixed from the following range:

Flake white	Ultramarine
Cadmium yellow	Cerulean
Yellow ocher	Viridian
Light red	Ivory black
Cadmium red	Extras:
Alizarin crimson	Raw sienna
Raw umber	Cadmium orange

Laying out paints

Put the colors along the top edge of the studio palette so that they do not rub against your clothes, neither too near the edge so that they slide off nor too near the center so that there is no room for mixing, a process which goes on all the time. A rectangular palette is probably a more practical shape for this purpose.

Color keys

Many color schemes in paintings are based on color 'keys', that is, a pre-
selected basic color relationship taken from the color wheel. The simplest
system would be a pair of complementaries, red and green for instance, but to
avoid harshness and monotony the whole gamut of hues (pure colors), tints
(mixed with white) and shades (mixed with black) are brought into play. If this
was explained in musical terms, then it would mean that a painting can be
composed in a certain key through infinitely subtle variations. This is not the
case if you introduce too many different colors into your picture. A large
number of opposite colors, instead of making the effect more interesting, in
fact end up canceling each other out. Strong color contrasts and strong tonal
contrasts do not live comfortably side by side on the canvas, although a sharp
accent of one color can be 'weighed' effectively against a larger but less
intense area of another.

A popular key is the split complementary, greens and orange, blues and red,
violets and orange, for example. Sometimes colors from one side of the color
wheel which are harmonious are mainly used, with perhaps small touches from
the opposite side, or large areas of grays tinged with colors are offset by pure
colors in small quantities.

Vincent van Gogh
Pear Tree in Bloom
In this picture there are in fact two
keys: the intense blue-green and
orange at the top, tinted with white,
shifts to the delicate violet and yellow
complementaries at the bottom of the
painting. This is a surprise as you
would normally expect to see the
more fragile colors near the top of the
composition. In each case the two
cool and two warm colors are in a split
complementary relationship as well
as the direct complementary one,
giving support to the overall harmony.
Although portraying the likeness of
the tree was important to van Gogh,
the highly sophisticated use of color
through the tonal keys was an equally
vital element.

Alfred Sisley
Le Repos au bord
du Ruisseau
The sense of cool
tranquillity has been
achieved by limiting the
tonal contrasts and
reducing the colors by
adding white to the
blue-green, green and
yellow-green mixtures.
The red, here a pink
accent, produces the
serene chromatic grays
when mixed with green,
its complementary.

The tonal painting

Tone is the means by which we register the lightness or darkness of a colored shape as it appears under a particular light. The evaluation of these tonal areas is important in composition, as well as representing the solidity of objects. Study them by making a painting without the added complications of color. First fix the upper and lower limits of tone, considering each part in relation to all the others as if they were flat shapes, and measuring accurately the lightest plane of the darkest object and the darkest plane of the lightest.

Interpreting the tones

1 2 3 4 5 6 7 8 9 10 11 12 13

Look at your group and try to mix and put down the main tones, from the lightest light to the darkest dark, with only black and white.

1 Plot out your subject fairly simply on paper with pencil or charcoal, defining the main shapes and directions and where the shapes overlap. Then, looking for correspondences and differences in tone, number each area, so that the highlight on the pepper would be 2, the shadow cast by it 7.

2 A half-tone ground on your canvas is a useful guide to help you evaluate the tones. It acts as a middle tone against which to judge the lighter and darker areas. Using just ivory, black and white lay in the shapes, including the shadows, with turpentine-thinned paint and a bristle brush.

Seeing tones clearly

Light tones next to dark ones appear lighter than they are. Squinting at the subject with half-closed eyes (far right) cuts out extraneous detail, making it easier to gauge similar values.

3 With mixtures from only black and white, build up the larger dark masses before the lighter shapes, keeping the tones exact across the picture without any jumps by referring to each shape and your linear drawing, which now bears little resemblance to this final tonal stage.

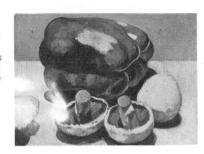

Painting in warm and cool colors

Apart from the tonal values of colors, the painter must also distinguish between warm and cool. Most people are familiar with the idea that reds, oranges and browns are warm while the cool colors are grouped at the blue end of the spectrum. However, each color itself can lean toward warm or cool; you can have a warm blue and a cool green. Neutrals and grays can be either warm or cool depending on what color is put next to them (see p53). Light varies enormously in temperature according to its source, the seasons or the time of day.

Color temperatures

Artificial light (warm)

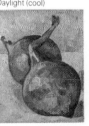

Daylight (cool)

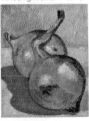

Mixed light (warm/cool)

Sunlight or artificial light accentuates the warm tones of objects, whereas a constant north light may give a cool feeling even to red objects. It is simply a question of looking hard and learning to distinguish the differences. In the first example artificial light creates warm tones; small cool areas appear in the shadows away from the light source. Daylight from a window to the left of the center group gives a cool silvery quality.

The painting on the right combines both electric light and daylight, which provides a whole variety of warm and cool tones. The cast shadows are not simply a mixture of black and white but contain warm and cool colors which can range from violet to blue. As can be seen in the scale above, when Indian red is added to gray it makes the cool gray progressively warmer. The onions themselves, and the mushrooms opposite, each represent subtle tonal changes.

Color behavior

Color is not necessarily bright nor is tone dull. They are modified in appearance by light and shade and by the way they interact: colors adjacent on the wheel tend to be harmonious, complementaries vibrate. The relative weights, warmth or coldness, shapes and their edges all affect behavior. What artists have to overcome is to paint something in the color they *know* it to be instead of the color they *see* it to be.

The definition of color

Hue means color at full saturation, that is any pigment straight from the tube unmixed with another color. Its intensity or saturation describes its strength or weakness. The mixing of white progressively gives a range of colors called tints. Though it is normal to mix white to obtain these tints, black should not be used unthinkingly to darken or subdue colors as muddy 'dead' colors may result. The further apart the colors are on the wheel, the grayer will be the result when they are mixed, so that complementaries will produce subtle and unusual browns and grays.

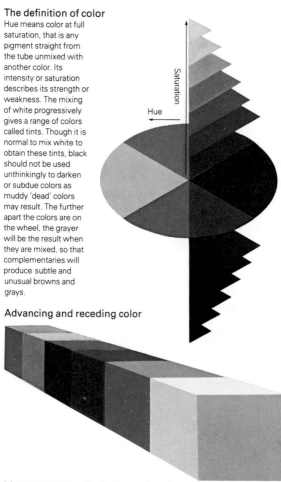

Advancing and receding color

It is a common assumption that warm colors advance and cool colors recede. More accurately, more intense colors come forward but so do strong contrasts, impasto and a textured paint surface. In fact, the further any color recedes from the eye, the more the atmosphere intervenes and cools it off, so that less intense or grayer, cooler colors and close harmonies go back.

Thomas Gainsborough
The Blue Boy
In the eighteenth century it was held that the proportion of warm to cool in a painting should never be less than four to one. Gainsborough's *Blue Boy* overruled the dictum that warm colors should be in the foreground and cool colors in the background where they would not dominate the composition and offend the eye.

To create the illusion of space and movement within the picture plane the painter is just as dependent on shapes as on warm and cool or color intensity. Consider the possibility of two simple shapes that overlap one another. One appears to be in front of the other regardless of its color.

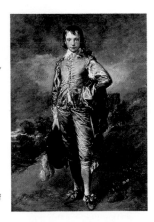

Color activity

Colors have their own energy and interaction. Look intently at all three squares in the row. In spite of the fact that the blue squares are identical, their color and tone appear to change in relation to the surrounding sea of color. Notice how the torn edge of the blue square has more impact than the straight edge. In the second row the same gray square is tinged with green when on the red, looks light on the blue and shifts to darker when against the yellow square.

Although the blue is the same tone in each example, it appears quite different.

The properties of all colors are altered by those adjacent to them.

Colors close in tone enhance one another; strong contrasts lose strength.

Toned grounds

Although many painters prefer the added luminosity a white ground gives, or find it easier to make precise judgements about color, a tinted ground can often be less intimidating for the inexperienced. There is a natural tendency to want to cover the canvas quickly with large patches of color to counteract the whiteness. You may want to leave some of the ground exposed in your painting, in which case you could choose a tonally complementary one, or a warm ground for a seascape as a foil for its cool blues and grays. You may use it as one color or the middle tone in a sketch where speed is often crucial, or cover it up entirely. Even if completely invisible a toned ground will nevertheless affect all the colors put on top of it.

A coarse canvas or prepared oil painting board can be improved by adding white pigment to the toning. Its heavy consistency fills in any irregularities on the surface but it will take longer to dry. It can either be painted on within a week, in which case it dries with the pigment of the finished painting, or left for up to a year, otherwise the paint may craze.

Prepare toned grounds at least two weeks before a holiday trip so that they are thoroughly dry. If the toning is still wet and gets wiped off, revealing the white ground underneath, try to make the most of this white in your composition.

Laying a toned ground

1 At the end of a day's painting the grounds can be mixed from almost any combination of paints left on the palette to tone some other supports. The toning goes over the white primer, whether it be gesso, emulsion or an oil undercoat. Mix the pigments on the palette with turpentine which dries fast and dries mat. Use a rag to do this.

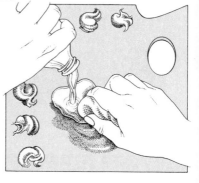

2 Rub the color on to the primed canvas or panel with a rag, getting it reasonably even. It should look inviting to paint on. Cerulean, ultramarine and raw umber make a useful cool ground, mars violet and raw umber a warm one, and yellow ocher and raw umber a dark ground. Make sure it is thoroughly dry or you will paint it away with the brush.

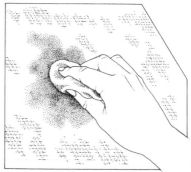

Underpainting

A toned ground gives an overall color and sense of unity (sometimes a false one) to a painting. Although the painter does not quite know when the ground is laid how specifically it will affect what goes on top, it can lead to rich glowing colors and to a harmony in the composition, as well as often being left to show through.

Unlike a toned ground, underpainting goes on the canvas in definite areas worked out beforehand and carefully positioned expressly to have an effect on what color goes over it, to set off another color and to act as a foil. The increasing transparency of the upper color allows the lower color to show through. Giorgio Morandi, the twentieth-century Italian painter whose still lifes are particularly outstanding, used violent reds and greens over which he painted quiet grays. If you were to paint a green apple over red underpaint it would differ tonally and in color temperature from a green apple laid over blue.

Some people apply the underpaint using acrylics which dry quickly. Turpentine or white spirit as a medium with the paint also dries fast but in the interests of quick drying do not be tempted to use a greater proportion than two thirds turpentine to one third oil. You will find that some pigments dry more quickly than others, such as raw umber, cobalt blue and Venetian red, while others take much longer. Mediums such as sun-thickened linseed oil and stand oil are thick and are reputed to enable you to paint on top of a layer of wet underpaint.

How to apply underpaint

1 Mix paint with turpentine and about 15% oil, making quite a lean mixture. Pour out a little turp at a time, finishing it before putting out more. Lay in the basic shapes or tones.

2 How the next layer of paint is affected by the underpaint depends on how it is applied. Often the paint is dragged across the underpaint allowing it to show through.

Some painters apply underpaint in just one color, others use several different tones, building up the surface in increasingly 'fatter' and more opaque paint. Some simply stain the canvas with a thin wash of color. As a general rule predominantly cool pictures are painted on warm grounds and warm pictures on cool grounds. (A warm picture on a warm ground would look very 'hot'.) This is a more considered approach to painting which does not suit everyone's style.

The Renaissance painters achieved their luminous skin tones by underpainting a face in a cool green, thinned down with medium, building up the strong modeling of the cheekbones in a darker tone and the highlights in a pale whisper of color. When the warm pink flesh tones were slipped over the top they were affected by the shading underneath and appeared coolly beautiful. You can see this for yourself by noticing how the creamy colored skin of the inside of your wrist makes the red blood in your veins appear to show through as a cool blue, something that both Rubens and Gainsborough had noticed and made full use of in their portraits.

Color observation

Children are amused for hours by painting books full of outlined shapes which they fill in with color. In nature, by contrast, there are no outlines to be filled in. Delacroix said, 'We don't see the blades of grass in a landscape; the idea of lines does not occur to us.' Nature does not define where one thing begins and ends, nor where one color starts and finishes. Color is always on the move, affected by light and shadow, atmosphere, other colors and reflected light from other objects. A seemingly dreary color will set up a vibration when set off by another, A warm color glowing on the canvas will be altered if an even warmer area is put down beside it. No color functions in isolation. What the painter has to learn to do is to put down the colors he sees, the observed color, rather than the color he thinks the object is, its local color, and to appreciate that paint, for all its subtleties, can never match the constantly shifting colors in nature.

Choosing a subject

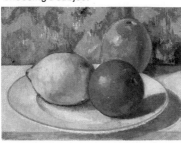

To sharpen your sense of observation set up a few objects, either in closely related colors or perhaps all red or all green objects. Arrange them simply as you will be rendering the subject in abstract form as patches of color, observing closely the relationships between each one.

Materials you will need

Take a board or canvas and use a brush which will give you one stroke per square of the grid you will construct. See that your still life fits comfortably within the rectangle and is arranged so that a single source of light falls on it.

Making the grid

Cut out a cardboard frame, leaving a window about 10×12in. (You could use a picture frame.) Stick in thumbtacks at precise ¼in intervals on all four sides. Loop fine gray knitting wool first in one direction and then the other around the pins to form squares. Prop up the grid between your canvas and the subject so that the still life is contained within it.

Now mark off corresponding ¼in divisions along the top and one side of the support. Use a set square to connect up the points. A view from a window can also be treated in the same way by drawing a grid on the glass. Or a still life can be set up to reflect in a mirror, the mirror squared up and the grid transferred to the canvas.

Mixing colors

Set the palette as you would normally. The colors that are not apparent in the subject may still be needed in the mixtures. It is almost always necessary to mix colors to get what you want. Rarely will two colors from the tube be right without adding another color or a touch of white.

The color exercise

Assess and remix the colors on the palette until you get them right, never on the canvas. If you want to change a color already put down, scrape off the wrong color with a palette knife or wipe it out with a rag. It is usual to overpaint areas in layers and these should be allowed to dry before a correction is made.

First sketch in the main shapes, then start with the most obvious color or, if in the same color family, compare and modify each area. Keep the patches in the right place and the right proportions. Color differences cannot be judged in isolation; they are always relative to each other.

Line

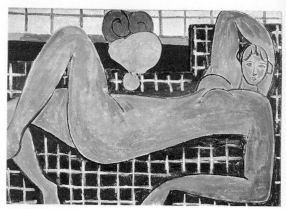

Henri Matisse, The Pink Nude

A sense of the directions of lines is essential to all figurative painting, and drawing too. This does not mean an accurate rendering of a straight line – that can be done with a ruler – but a sense of where lines are going. Pared down to its bare essentials a painting without the benefit of color, tone and scale is nothing more than shapes on a two-dimensional surface connected by lines and directions, imaginary or stated.

What lines do

1 Lines divide the rectangle both horizontally and vertically, imply direction and distance, provide an eye level and clarify perspective.

2 Lines define shapes and give them emphasis, as well as denoting the boundary of a silhouette. They also provide a contrast to the flat areas.

3 Lines can be used to create or to build up textures by their color, weight, repetition or angle, and by the significance of the mark.

4 Lines establish axes through forms. They can be either straight or curved, not simply horizontal or vertical, and can link up shapes.

The qualities of line

Line makes a shape as well as a line. In the painting opposite, the line at the raised knee disappears where the light is probably striking it, while at the calf it is thickened or defined to suggest mass or form. The line can contain the shape within its boundaries, varying in weight (thickness or thinness), in pressure, in tone, in energy, in brightness. It can be washy, dry, soft or hard edged. If you paint a line on top of wet paint, the brush picks it up and this softens the line; if it goes over dry paint, the line tends to look hard. Bristle brushes give a varied line, the shape depending on that of the brush; the line formed by a sable brush is fine and definite. If the line is the same width all round, the shape of it implies that the picture plane is flat. Although it is easy enough to repeat the same mark – and many painters do – one as seemingly straightforward as line should be put down for a reason and should remain as sensitive and necessary as any other mark you make.

Painting in line

1 Work with the darker line first, painting the light color up to it, which softens the line.

2 Painting a dark line on top of a light color makes it emphatic, just as leaves painted on top of sky look hard.

3 In this case the paint is not taken right up to the line. The underpainting is visible to indicate light on the form.

4 Lines have shape and shapes have edges. Painting over the line can give the impression of solidity.

Counterchange

In any scene, if you look for them, you will find that there are dark elements coming against light ones, which make a foil for light elements coming against dark or middle tones (all often in the same subject). It is an induced contrast which forms a delightful painterly device.

In *The Pink Nude* there are dark squares on light and the reverse.

Here there is a dark shape against light and light against dark.

Shape and form

The difference between flat shapes and solid form is the way that the light falls on the object and makes one conscious of the solidity of things. Of course there are no rules to say that solidity must be represented by light and dark. It is simply one of the languages of form. A silhouette by its edge gives the impression of solidity. If you were to paint an even edge all round an apple, for example, it would look like a cardboard cutout of an apple. A contour, on the other hand, is affected by the way that the light falls across the form, obliterating the edge towards the light and defining it on the dark side. The painted edge does not stay on the outline and these 'lost' and 'found' edges indicate its volume.

Flat and modulated shapes

Color in itself is inadequate to describe form. For instance, if you were to take three objects painted in different colors but not illuminated from a particular light source, you could make them look totally flat, that is completely without form. Because of the intervening atmosphere, the further away an object from the eye, the flatter it looks; the closer it is, the more apparent the variation in its color and in the degree of modulation, which indicates the apple's position in space.

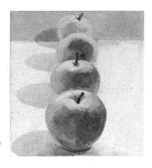

Representing three dimensions

As it is not possible to actually create three dimensions on a two-dimensional surface, the best you can achieve is an equivalent through the use of tone, the modulation of color and the edges of the shapes.

In drawing you assume the things in front of you have no color and to realize their form convincingly you impose on them, by means of shading or the use of light and dark, a system which represents form or mass. This is not true of painting. One cannot assume that everything will look solid by drawing each object with a light side and a dark side. It is the way in which the color is interpreted on the canvas that creates solidity and planes. Cézanne realized that each plane, turning from the light, became a different color.

As a color modulates, lit by direct or reflected light, it moves through one color to another across the form. Amateur painters tend to over-model and this can lead to a jumpy or fractured picture surface. Shadows, too, are subject to light and dark, as well as moving between warm and cool, and their subtle color variations can often be obtained by mixing complementaries.

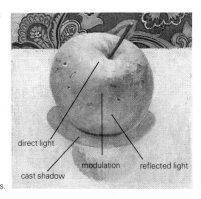

direct light

modulation

reflected light

cast shadow

Creating depth on the picture plane

As well as describing solidity and form, shapes also constitute part of the tonal or color pattern in a picture, while the warmth and coolness of the colors of the shapes and their intensity denote their position in space. You can check this for yourself by cutting a piece of colored cardboard into three. When each piece is seen at different distances they look dissimilar yet many people would be tempted to paint each one an identical color, ie their local color, despite their obvious differences to the naked eye.

The illusion of depth on the picture plane can be generated in two other ways: by the relative scale of the forms themselves, and by the overlapping of the shapes which tells you by the drawing which object is in front of or behind another.

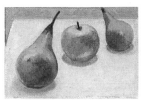 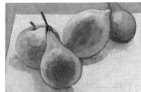

The increase or reduction in size and the directional thrust of the pears suggest depth in the picture. The eye automatically tracks along or extends a line defining shapes and tonal areas.

The way in which the shapes of the fruit overlap implies that they are on different planes. Notice the many small changes of color and how subtly they melt into one another.

Edges

Flat shapes are represented in three dimensions by the manner in which the edge of the shape is treated. A broken line, a strongly defined one, or simply an indication of where one area of tone ends and another begins, reveals the amount of solidity. Since we have two eyes we actually see two edges to a form. Cover first one eye and then the other and you will see how an object you focus on will move. This facility, which the camera with only a single lens lacks, helps us to recognize that something is round.

Define edges as you go along, building up the paint rather than putting down what you think is there and then re-stating it.

Wall and table are considered at the same time as the fruit. The edge of the lemon is defined away from the light but 'lost' where the light falls full on it. The cast shadow modulates from warm to cool in the reflected light of the lemon, one edge sharply delineated or 'found', the other edge being fuzzy and soft.

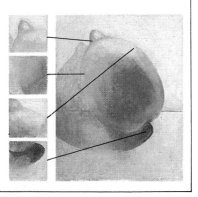

The balance of shapes

Painting is about relationships – the relation of one object or shape, color or curve to another. Fitting the separate parts together in a satisfying way within the rectangle (the most common format) is what is meant by composition. It should not be a mechanical arrangement of unrelated ingredients, however. Composition nowadays is not necessarily a matter of classical order or mathematical precision (although how the rectangle is divided up is undoubtedly an important consideration, see p68). It is more likely to be a response to the compositional possibilities within the subject and an awareness of the devices used to develop a harmonious relationship on the canvas. Ideally, the picture should grow, or take its form, from the subject itself.

Everyone will react differently to the same subject, whether it be landscape, still life or figurative painting. One person will prefer the rectilinear shapes, another the simple areas of color. First look for these structural devices in other people's paintings and try to pinpoint why a particular picture appeals to you. Are there complex shapes played off against something stable; intense color contrasted with diffused; a definite curve echoed in smaller, less defined curves? All these contrasts will be there if you train your eye to recognize them. Of course, they will not all appear in the same painting for the surface would appear fractured and disjointed, but without them the work would be predictable and boring.

Passive shapes against active shapes

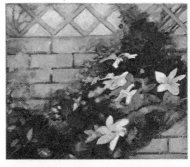

Horizontal and vertical elements in a painting give symmetry and stability and can be set off by active, organic shapes, or by bisecting the rectangle with a diagonal force line.

Complex versus simple shapes

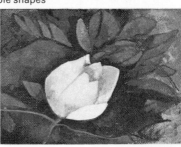

Some of the most satisfying pictures are the simplest. Pin your tonal drawing to the easel to refer to when breaking large areas into more complex ones.

Large shapes contrasted with small shapes

The simple shape of an expanse of water is played off against the lively reflections of the lily pads, the flowers and ripples, delighting the eye but not dominating the picture.

Positive and negative shapes

Composition is not just about arranging or defining shapes but, as already mentioned, about balancing or contrasting one area against another. It is a question of creating an equilibrium in the picture so that forces set up within the rectangle are contained, are pleasing to the eye and hold the interest, and combine harmony with variety. If the picture plane were to be divided symmetrically with a centrally placed horizon or tree, for instance, the effect could be dull and boring, and the composition would tend to fall into two halves.

The spaces between the shapes, whether it is the leaves on an oak twig or a group of objects in a still life, should be given as much thought as the primary shapes themselves. These 'between' shapes should not be treated as background to be filled in later but considered as vital clues to the main shapes, the inter-relationship of the objects and their position in space.

Accurately observed negative shapes can be very helpful to check the accuracy of the positive shapes and establish the form of the composition. Try this experiment. Make a series of drawings of only the negative spaces between the branch of the tree, the leaves and the flowers, filling in these areas in black. You will see that this makes the negative spaces positive. Notice how the spaces between the curves made by the flowers, leaves and twigs are as full of life and energy and as significant to the composition as the plant forms themselves.

Transcribing a painting

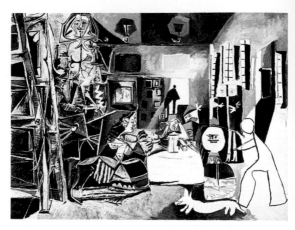

One of the best ways of learning to structure a painting into a coherent composition is to look at other successful pictures – not to imitate their style or subject matter but to see how they are put together. A particularly useful exercise is to paint your own versions of works you admire. These transcriptions, as they are called, should be more than copies. Great painters such as Picasso, Rubens and Rembrandt, for example, did not hesitate to learn from the work of other artists by freely reinterpreting them.

A transcription is a painting about a painting. You should try to discover how the picture was built, why the lines and planes are placed as they are and how colors and tones are distributed over the picture surface – the same elements you should consider for your own work. In this way, you will learn to see the surface of the picture as an interlocking whole.

Picasso painted this interpretation of Velasquez's famous *Las Meniñas* when in his 70s. You will see that he has changed the whole emphasis of the painting. The soft, golden light of the Velasquez is made harder and more fragmented, in a horizontal format. Note how the figure of the artist, one of Picasso's main preoccupations, is made much larger and the dark figure in the cape becomes almost menacing.

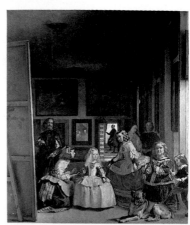

Making a free copy

Visit a gallery and make quick sketches of paintings that appeal to you. Then complete linear and tonal drawings of the painting you like most, giving yourself enough information to work up the transcription at home.

Choosing a painting

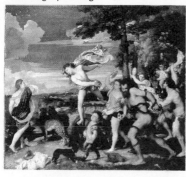

A figure painting such as Titian's *Bacchus and Ariadne* (left) is more challenging than a landscape or portrait. Choose the one that is most intriguing compositionally. Then decide which aspect interests you and explore it from that viewpoint. Is it predominantly linear or tonal? Is the composition based on geometry (p68)?

Investigative drawings

1 You could make a linear drawing in charcoal, pencil or paint to explore the rhythms and spaces. They fall into two groups – the procession moving in from the right and the single figure of Ariadne on the left. A diagonal line drawn from bottom right to top left fixes the prominent figure of Bacchus, to whom all the movement of the figures in the painting is directed.

2 The tonal drawing, on a fairly large sheet of pad paper, should represent the pattern of light and dark across the picture surface. Match the true values of these tones by comparing one with another. Another way of doing this is by means of collage – gluing down pieces of paper torn or cut into shapes from different sources to give blocks of varying tones.

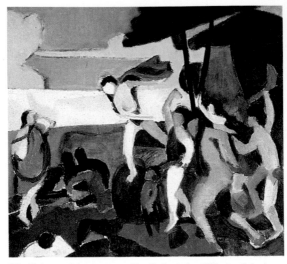

3 The final transcription attempts to identify the design of Titian's painting in broad shapes, while noting the main tonal and color relationships.

Free interpretation

Degas' *After the Bath* is a complex composition that relies on subtle tonal contrasts within a limited palette of warm colors. The satisfying unity of the composition, with the flowing shapes of the towels complementing the rounded forms of the figure, balances the drama of the pose. In the transcribed drawing, it is the latter that becomes most important, and in the painting (involving a change of medium from pastel to oils) the colors are heightened, giving a more direct impact.

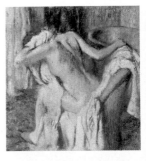

see also pages 10–
13, 72–73

Format

Just as important as your skill at drawing and painting – probably
more so – are the preliminary steps you take to plan the finished
work in your mind's eye. The initial idea may change as you
paint, but if you have established a sound basis the changes you
make may be real improvements rather than attempts to correct
something that was fundamentally wrong in the first place. The
key to this is composition – having a clearly worked out structure
toward which you are working. First of all, having chosen the
image you want to create, you must decide the format. Choose
the shape of your canvas or board in accordance with this
intention rather than attempting to squeeze the idea into an
unsuitable shape.

It is not just a matter of
convention that some
shapes are more suited
to some subjects than
others. A standard
rectangle 1 will allow
the eye to move slowly,
settling on areas of
interest in turn. An
elongated shape 2, on
the other hand,
encourages free lateral
movement.

1

2

4

Squarer shapes 3 are difficult
to structure effectively. The elements
of the composition need careful
positioning. The upright
rectangle 4 emphasizes verticals.

3

Harmony and proportion

There are several methods for dividing up the surface of a painting to achieve a balanced and satisfying whole. Remember that these exercises in geometry can only create an underlying structure, and they rarely make effective subjects in themselves.

The Golden Section divides a composition particularly effectively. **1** Take a strip of paper and mark the length of the base. Fold it in half to find the mid-point. **2** Mark this distance up the vertical side and take a diagonal to the base corner. **3** Mark the same distance back along the diagonal from the vertical and draw an arc through it to the base. **4** The arc will cut the base at the Golden Section. **5** To find the height of an ideal rectangle from this divided base line, with a square formed by the larger segment, mark the mid-point of the larger segment and draw an arc through the corner of the base furthest from it. Where this crosses the Golden Section vertical will indicate the desired height of the underlying rectangular structure.

To build a Golden Section from a square, take the mid-point of the base of the square and draw an arc through its top corner (left). Where it crosses the extended base line will mark the edge of a rectangle including a square defined by the Golden Section. From this ideal shape (right), any number of subsidiary Golden Sections can be plotted from the crossing of the diagonals of the whole rectangle and the smaller segment.

Diagonals

Powerful unifying lines can be found along the various diagonals to be found in a composition. The squares of the rectangle, on either side as shown in the diagram, provide extra diagonals. The zigzag produced by all three can even be used as a device to unite the composition.

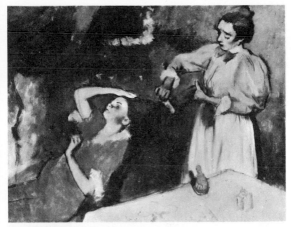

Edgar Degas Combing the Hair
Degas painted scenes from everyday life in a free technique that disguises the underlying structures that give harmony to his work. Here, the main division of the subject, between the woman on the left and her servant on the right, corresponds exactly to the Golden Section.

Almost every element in the relaxed design seems to have been placed with a purpose. The woman on the left falls along the diagonal of the square formed by the Golden Section, with her center of gravity on the square's mid-point. The woman on the right stands solidly in the center of her segment.

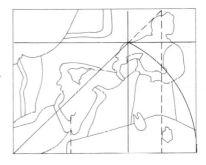

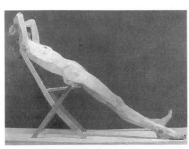

Euan Uglow
Diagonals
At first sight, Uglow's figure seems to be placed directly on the main diagonal of the canvas. By tilting it off this line, however, an element of tension is introduced between a static idea and its altered execution on the canvas.

69

Found composition

You can either start a composition as a design which you impose on the shapes and colors of the painting or you can 'discover' a pleasing scene that already has the compositional features you want. The latter is the course taken by most outdoor painters, those for whom informality is an important aspect of the work. This does not mean that harmony and proportion can be ignored – they are often the key to the success of the pictures that look least planned. Claude Monet, as an Impressionist, insisted on the validity of unelaborated visual experience, but his *Two Women on the Beach* shows a profound grasp of the principles of composition.

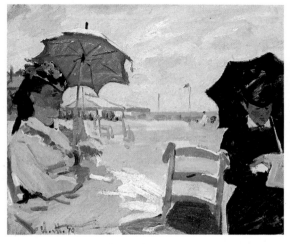

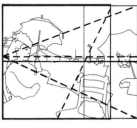

Monet painted the scene very much as he found it, but was also aware of an internal pictorial structure. Always try to find such elements – they will give your work cohesion and balance. In Monet's picture, several factors are involved. First, it is divided into two main parts by the Golden Section (blue). The square of the rectangle (red) forms an independent composition, defined by the vertical made up by the chair back and right-hand-woman's parasol. The horizon, placed just above the lateral mid-point, provides a focus for two main diagonals which mirror each other (black). Another diagonal links the top and bottom of the picture. To achieve balance (below), the dark figure to the right is offset by the larger, less heavily shaded woman to the left, the whole effect being a stable but natural composition.

Imposed composition

For some artists, composition is the all important factor, perhaps even the subject of the picture itself. More frequently, an imposed composition is used as a hidden, underlying structure into which the parts of the picture are subtly fitted to create order and balance. This is essentially an intellectual approach to art, and often stems from a preconceived set of aesthetic rules. The criticism, of course, is that such a considered and detached way of planning a painting will reduce the spontaneity of the artist's creative act, producing dry and mechanical images. While the danger is there, it can easily be overcome. Ruisdael's *Landscape with Ruins*, for example, looks for all the world like an uncomplicated view of a real place, painted from observation. In reality, it owes part of its success to a carefully worked out pictorial structure, with each element controlled by the overall design, although this has not been allowed to dominate the effect of the painting.

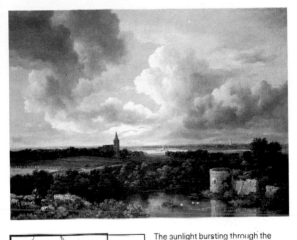

The sunlight bursting through the passing clouds gives Ruisdael's picture great freshness and movement. At the same time, the picture is very carefully organized. The church spire, for example, divides the painting exactly on the Golden Section and the horizon does the same laterally (blue). The ruined tower on the right defines the square of the rectangle (red) precisely. Both these devices create stability. By contrast, the V formed by two diagonals in the foreground (black) leads the eye back into the picture. The artist also created tonal balance through the picture by inserting a light element into the dark foreground with the ruin at the right, corresponding to the dark clouds in the light sky at the top left.

Preliminary investigation

A still life, more than any other subject, provides an opportunity to explore the relationships of color, tone and shape. It neither moves nor breathes so you can study it for as long as you like, then decide what you find most appealing and how you are going to tackle it.

The simplest still life consists of one motif – an apple for instance. Two apples require arrangement. One can be put in the shadow of the other, be cut by the edge of the canvas, or its shadow can form a third shape. Larger groups of objects may appeal because of the pattern they make or their symmetry. Still life gives you a chance to experiment with unusual shapes of panels – long and thin, or tall.

Masking the subject

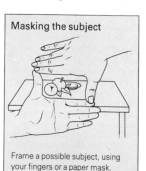

Frame a possible subject, using your fingers or a paper mask. Explore every potential viewpoint.

Looking at the subject

When painting from direct observation, the artist has to make two choices: where the viewpoint will be and how much to take in. Both these decisions depend on what has excited you about the scene. A bag of shopping on a kitchen table or tools on a workbench will be on a single level so you might work up close, keeping an eye on the slight distortion of the perspective. From a greater distance you could throw open some cupboard doors and paint the contents ranged on the shelves at various levels. Do not leave out unattractive or difficult objects.

Pencil sketches

1

2

3 **4**

Pencil drawings teach you to see the picture possibilities in a scene, enabling you to understand the shapes of individual objects and how they relate to one another. This will sharpen your sense of observation – more important than style at this stage. Try to see the broad forms rather than details. Simple line drawings **1** will show how objects relate in outline shape. Additional modeling of the forms **2** will begin to indicate the tonal areas. Even the most simple elements **3** may be sufficient, and moving in close **4** may give a more unusual and interesting view.

The palette

You will soon learn that you use more of some paints than others. White, for example, is needed to lighten many other colors. Even the most unlikely color, not appearing at first glance in the objects you are painting, may well be present in combination, so put out the full range of colors you might expect to use. However, too many colors in the composition can be confusing. The color harmony of the group is important to maintain – do not be carried away by bananas, plums, cherries, apples and oranges on a green cloth. Ask yourself, what are the predominant colors.

Starting on the canvas

Although many painters start off with underdrawings, these do not have to be elaborate. In fact, you can draw straight on to the canvas with a brush, diluting the paint with turpentine. Quick-drying ultramarine or raw umber will do for this. Plot the main directions, divisions and axes by referring to the subject or pencil sketches. Lines dropped from various points establish how shapes fall under one another. By this method, called plumbing, a rudimentary perspective is arrived at.

Paint 'fat over lean'

For fluid paint with which to cover large areas use only turp with the pigment. This 'lean' paint (bottom) dries quickly. With each next layer add linseed oil to the turp – not more than one part to two parts. This is 'fat' paint (top). Do not then go back to using turp only.

One-off sketch

On a small panel take an initial drawing through to the end in one go. Start with a ground colored to represent the middle tone. Take care to establish the relationships of tone and color first time, making sure not to exaggerate the lightest or darkest tones. Spend 30 minutes on this sketch to see how much you can achieve. Mix up the largest area of color, here the table top. It is most unlikely that pigment straight from the tube will be accurate – other colors will have to be mixed with it. Now try to match the color of the apple as compared with the colors next to it. Working on several areas of the picture at once you will soon see how strongly colors are affected by those next to them. The color changes in the apple are more obvious but can you find any in the plate? In your first efforts the edges of the colors will probably meet in a definite line, but you should try to appreciate how colors in life blend into one another.

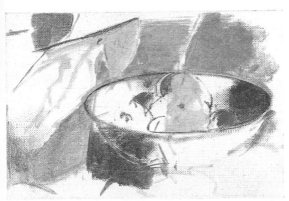

Another method of starting is to underpaint major areas in tones of a neutral color or a color close to the one you want. Mix enough of the main colors on the palette to cover all such areas thinly. Keeping to three main tones, apply the thinned paint with a large brush or a rag. To do this you must identify the lightest and darkest tones right at the start. Leave the lightest tonal areas clear and put one touch of paint on each. It is often a good idea to make a tonal drawing rather like a jigsaw puzzle. Referring to this will stop you straying too far to either the extreme light or dark end of the tonal scale so that small areas of high contrast will have greater effect.

Shadows are often difficult to paint. The shadows cast by the apple, the plate and the knife are not composed of pigment darkened with gray or black but are colors in their own right. They are also either warm or cool depending on the source of light and on the local color of the object that is casting them.

75

Looking at the composition

One of the pitfalls the painter must guard against is a tendency to represent everyday objects as they are expected to appear rather than as they actually appear to the eye. Instead of direct observation of what is in front of you, preconceived ideas of what a bowl of apples or a plant should look like take over. Familiar objects are most likely to be subject to this fault – trees and sky in landscape, or the human form, for example. Always attempt to see the subject as it really appears, reduced to a pattern of shapes of color and tone.

If you have followed the procedures on the previous pages, the first exploratory areas of color will by now have been laid down and the tonal divisions between light and dark defined. As you develop the painting, work over the whole canvas rather than concentrating on detailed passages, which will make it very difficult to judge how each color relates to its neighbor. Try to work quite quickly, without rushing, for a controlled sense of urgency will help to keep the picture fresh, a quality that is much harder to maintain if you work over a period of days or weeks. Perishable objects in a still life, such as flowers, certain fruits or fish, for example, should be worked on more quickly, perhaps developed in advance of other elements in the arrangement.

A balanced structure

Every painting will have its own tempo, with unforeseen setbacks and even major reworkings occasionally involved. When you have a large part of the surface blocked in, however, you should pause to assess the structure of your work so far. Many of the decisions will have been considered fully at the planning and drawing stage, but at this point new factors must be looked at, such as color and tonal balance.

Areas of tone and color and specific shapes can all be said to have values or 'weights'. Dark areas, for example, have greater weight than light areas. A small area of intense red or blue on one part of the canvas will have greater weight than a larger area of more neutral gray-green elsewhere, even if it is of the same tone. In the same way, shapes with clearly defined edges will weigh more than those with softer edges. It follows that all the dominant shapes and saturated colors should not be grouped on one side of the canvas with amorphous shapes and neutral colors on the other if you want to achieve any sort of balance.

Reflected view

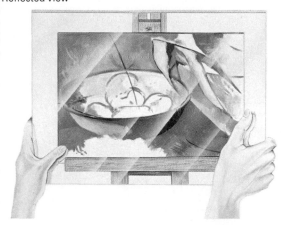

Looking at your picture in a mirror gives a fresh and unexpected view and will often draw your attention to any problems. A reflection reverses the image from left to right. In this unfamiliar form, it may be easier to weigh up the composition objectively. Ask yourself whether what first inspired you is still evident. What makes it special? Is it the pattern of light and dark, the color, the intriguing shapes, the way the light falls? One of these elements should usually have priority. Look for the focal point of the picture. This can often be where there is the greatest contrast or where the most dominant shapes or colors meet.

Inverted view

Try turning the painting upside down on the easel. Stand right back from it and analyse it. Is there a satisfying arrangement of interlocking areas? Is the eye held in the rectangle or diagonal lines or rhythms lead it out? Is there a main point of interest or do several things compete for attention in the composition?

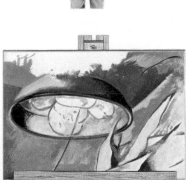

Developing the painting

A satisfying composition is one that weaves itself into a cohesive whole. Whether you work from the large areas to the small or start with the small and build up the relationships across the canvas does not really matter. The important thing is to make constant, careful comparisons of similar colors and tones.

When you have checked the composition and defined the main colors and forms, you can continue in several ways. Try starting with the area that interests you most. Or you can deal with the parts where things join up to one another – in this example, the point where the bowl, background and flower pot are connected. Look across the whole canvas and put in touches of color that are repeated between different areas.

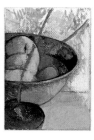

Work on related areas simultaneously with small touches, fixing the transitions and contrasts across the shapes. Try to find the differences and the connections. In this way, the complete work is more likely to have unity across the whole surface.

Working from larger areas to details

If you feel happier working with larger brushes and generous amounts of paint rather than small touches or marks, concentrate on whole areas, building up from one of them. For instance, establish the background wall, the bowl and the table top before building up the apples or the texture of the plant pot, remembering that you should be working from the translucent darks up to the opaque light colors. When working in small touches, the order in which you apply the paint is not so critical, and any adjustments you want to make can be built up on top of the previous marks. But when making changes in larger areas, scrape the paint off down to the canvas with a palette knife to prevent the surface becoming sticky and overloaded with paint. Make such alterations freely.

The background should not be treated as a large nondescript area but considered as important as the objects in front of it. Wall and table top should not be left until last nor painted first with the bowl superimposed on top of them. It is best to build the background areas out from the main areas of interest. Although a wall may appear to be a flat color, it is very much affected by the light coming to it. Here, the table top, too, is not a uniform color but subject to the reflected light and cast shadow of the bowl. Consider the overall color and tonal relationships.

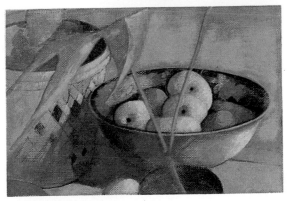

Restating and alterations

One of the beauties of oil paint is that, depending on how thickly it is applied, it can take several days to dry. On a non-absorbent ground such as a wooden panel you will be able to work on it for some time. Even on canvas or board, it will be possible to restate parts or make substantial changes if they are required. There is a danger, however, that a picture will lose its freshness with repainting, particularly if it is worked on over a long period, In general, try to avoid too much tinkering, but be prepared to make broad changes when you can see clearly what has gone wrong. Tentative and experimental brushstrokes are unlikely to produce the results you want. Instead, work boldly and remove the sections of paint that do not match your intentions. Always think carefully about alterations, perhaps leaving the picture for a few hours.

'Tonking' with newspaper

 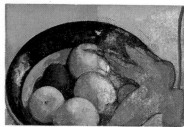

When the canvas seems to have become overloaded with paint and still requires further work, the excess paint can be removed by 'tonking'. Put a sheet of newspaper over the part of the picture that dissatisfies you, rub your hand over it and draw it away. This soaks up excess paint and softens the edges, leaving enough for restatement. The next day, the surface will be dry enough to work on again. This technique results in a dry, powdery surface since much of the oil is absorbed from the paint.

Scraping down with a palette knife

While the paint is still wet it is possible to remove the top layer and alter parts of the composition. Draw the knife across the canvas at an angle to remove the paint from the areas you are not happy with. This takes off more than 'tonking', but when you come back to the scraped parts of the canvas the image will still remain, although the edges will be lost. Scraping down clears enough paint from the canvas to allow you to see how you might start again, without the distraction or delay involved in overpainting. If painting in small touches, however, overpainting may be easier. Light colors are more opaque and will cover better.

Applying a glaze

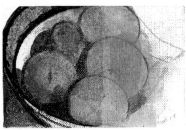

Color can be subtly altered, given luminosity, or a unifying element added, by applying a thin layer of translucent paint over the surface. Transparent or semi-transparent colors usually produce the most effective glazes, although their effect is more likely to be on the quality of the color than the tone. Light areas, such as the bowl here, can subsequently be painted over the glaze.

Restating edges

If shapes and colors are incorrect, it is quite possible to redraw them in paint. While you should attempt to position the elements of your composition correctly in the first instance, such reworking is a normal part of oil painting – it is an advantage of the medium.

Edgar Degas
Woman at a Window
Painting in thin glazes over a red ground, Degas was able to create a powerful image. Yet the deep shadow of the dress and the luminosity of the window have been laid over the stained canvas with a deceptive carelessness. The color of the ground shows through these two main areas, giving the picture a complete and convincing unity. The subtle use of glazes can give simple colors great depth and richness.

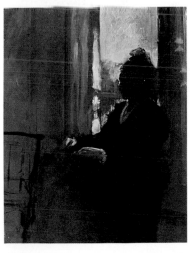

Composing a still life

Arranging a still life is not easy to pull off successfully as it is in fact two arrangements: the arrangement of the subject material and the arrangement of the picture on the canvas. There are no rules; it is simply a question of selecting from an enormous variety of beautiful things, from pebbles to peapods, that can form a still life. Choose objects that appeal to you. Don't take in too much or edit what is there. Think about the theme before you start. Your picture could be a single object or in groups; one object dominating the others in size or color, or varied shapes lined up in a row; an all-over pattern of similar small things or opened up with unbroken areas of flat color.

Now consider the support. Work on a fairly small scale, about a 12×20in canvas or panel. Will it have a white ground for luminous colors or a tinted ground for a predominantly tonal group? Use several round and filbert bristle brushes with medium-length, flexible bristles which will make drawing marks and also put down areas of paint.

Placing objects

First explore various viewpoints on paper. How will you arrange things within the confines of the canvas? Will the group be contained within the space or break out from it?

Be aware of the intervals or negative shapes between objects placed in a row. When objects overlap, look at the subtle gradations from warm to cool in the individual shapes.

Light

Although you can have two different light sources, one artificial and one natural, do not start off with one source of light and switch to another as this will radically alter the warm and cool values. Electric light will give clear, strong shadows and is warm so that colors such as yellow need care. Daylight is cool; shadows will be much more subtle. Shadows can sometimes link single objects that might otherwise be isolated.

Depth and background

Where will the horizon come? Is it to be a shallow or deep group? Will the picture be tall or long? Take it all in in one eyeful, about a 60-degree angle. Remember that you take in more widthways if it is not a very tall group and more in height if the grouping is not too wide. Look beyond your still life. Is there patterned wallpaper, the handles of a cupboard or the line of a window to include? Consider the play of textures, a surface quality which is a quite separate element from pattern.

Painting flowers

Flower painting has been underestimated – unfairly perhaps, for it is a popular and historically important form of still life. Generally it can be approached in two main ways: the first relies on a botanical style of drawing not really suited to oil paint, while the other is more painterly and makes the most of the medium's richness to suggest the color and vigor of plants. Pure colors in a mass require careful handling, but they will generally include greater variation than you expect. A red rose, for instance, is not entirely red – it will be crimson, scarlet, violet pink and peachy pink. The apparent delicacy of plants might seem impossible to convey in oils; try to capture their freshness and strength as living organisms, rather than to copy their precise outlines.

Diana M. Armfield
Spring Flowers
The placing of the cup divides the composition. The placing of the keyhole on the cupboard door brings the eye across from the dominant element. Background and table top divide the picture plane, and creases in the tablecloth introduce foreground interest.

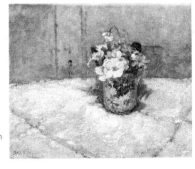

Flowers facing straight on command the most attention. They can be painted with greater definition and emphasis. The other blooms can be given a less finished treatment.

Build the flower heads as a series of portraits, each with its own character.

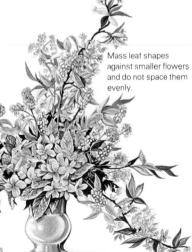

Mass leaf shapes against smaller flowers and do not space them evenly.

If the arrangement is lit from one side, the areas facing the light will be more detailed and defined.

Branches of foliage add graceful curves.

Choosing a container

A patterned vase can complement the real blooms or compete with them. In a glass jar notice the refraction of the stalks and the subtle color changes in the background.

Arranging flowers

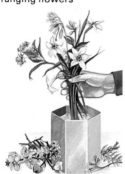

If you take flowers from the garden, choose a mixture of sizes, shapes and colors. Arrange them casually in your hand as you pick them, then put them straight into the container you have chosen to paint them in. Place the flowers informally so that they are not spaced too regularly, bearing in mind that you are composing colors and patterns. Cut the stems diagonally, and if possible put some foxglove leaves or a commercial product with the same enlivening property in the water and stand the flowers in it. Put them to one side. The next day they will stay in one position.

Points to remember

When rich colors are concentrated in one area, background can help to bring the eye away from this focal point. Highlights are seldom pure white but blue, violet, green or pink. Sustaining their luminosity may mean stepping down the colors of the other light areas.

In this detail from Diana Armfield's picture on the previous page, the primrose attracts the greatest attention because it is facing you, so it has been painted strongly. It contains both warm and cool colors – the pinky white is played off against a creamy green with violet-blue shadows, creating a translucent effect. The china vase modulates from warm violet blue on the right, cast by an electric light, to cool greeny blue on the left, where daylight falls on it. The vase is defined by shadows.

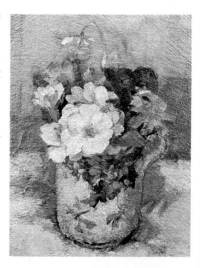

Starting to paint

Use the biggest bristle brushes you can manage. They will help you to see things in patches of color. Sables 'lick' the paint – and also wear out more quickly. If the ground is not too absorbent you will be able to go on pushing the paint around for some time. An absorbent surface will give a very flat, simple quality. A white ground will produce light, bright colors but may take more time to cover and the flowers could be past their best too soon. A toned ground will help you make quicker progress at the start – a warm ground for cool violet blooms, for example – and will give a rich and luscious effect.

1 With thin paint, establish a firm linear structure of the angles, curves and divisions you decide are important. Look for linking rhythms from one flower to another and between the edges of the shadows.

2 On this scaffolding mass the main shapes and colors of flowers and leaves, scrubbing in thin paint to suggest the whole composition. Indicate with touches on the canvas darkest and lightest tones.

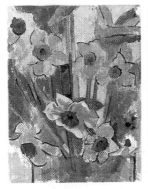

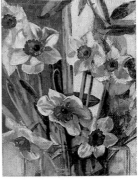

3 Now with fatter paint build up the key flower first, painting it as a blend of small shapes of modulating colors and subtle tonal changes. Then paint the one next to it and so on, varying the weight of color and edges.

4 Instead of concentrating on each flower in turn as in 3, you could work on the whole canvas simultaneously, refining shapes and colors. Work from the dark areas to the light, finally emphasizing one or two flowers.

Painting the figure

Figures, particularly nudes and portraits, are important subjects for artists. In addition, they are often the central element in pictures with a narrative content and, while it is not necessary to include them in landscapes or interiors, they will often provide a focus for a composition. Whatever your reason for painting figures, they are a special challenge, requiring extra care and preparation. Although stylization of the human form is quite acceptable, you should remember that the distorted figures in many paintings by modern masters are like that for a reason – it was not the artist's lack of skill that caused Modigliani to reduce his figures to elongated ovals, for example (see p92).

Edgar Degas
Nude Study
The first step in figure painting is to study the human form in drawings. Degas' sketch toward a major composition analyses the pose of the figure, together with the way the light models the figure.

Edouard Manet
Study for Déjeuner sur l'Herbe
Having worked out the poses of the figures and the general form of the composition, artists sometimes make full-size oil sketches. The free handling and simple forms of the sketch make evaluation of the composition's progress easier.

Studying tone and shape

Try to identify the main shapes and tonal areas. Working in pencil or charcoal, pick out the shadows. Mark the darkest area first, working in patches according to the lightly sketched outline. Add the middle tones, and choose the area that will be the most important highlight. This can be left as white paper or emphasized with white conté.

Squaring up

To transfer a small drawing to a larger canvas, divide it up with a grid pattern. This is usually a straightforward grid of vertical and horizontal lines, as on the Delacroix sketch. Transfer the grid to the canvas by laying the drawing on it and extending a diagonal. This will reproduce the proportions. Divide the rectangle into the same number of squares and copy the drawing on the grid.

A tonal painting

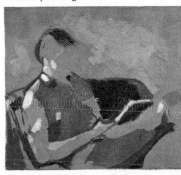

As a very useful exercise, try painting a picture in light and dark. Work on a ground that serves as a middle tone, adding the dark areas first, as with the tonal drawing. Use thin paint, in broad areas. Pick out the main highlights in a light-toned color. You should now have the general shapes indicated in position by areas of light and dark.

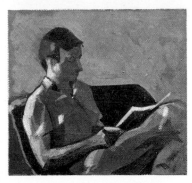

Use this simplified image as a basis, refining it but not altering it. Mix four tones of gray on the palette and adjust the neutral ground. Put lighter tones over dark to show the lighter areas. It is easier to paint light over dark than the other way round, but try both. Keep shapes simple and do not include the smaller forms.

Color and form

The main textures encountered in figure painting are flesh, hair and various types of clothing. Flesh is very important and requires the artist to look without preconceived ideas. It is never a simple, overall pink but consists of many colors such as reds or blue where tiny blood vessels come close to the surface. In addition, the different natural skin types have quite different pigmentation. The darkening of shadows and the colors of reflected light have also to be considered. Evenly lit areas of skin may consist of a single tone but be full of subtle color variation. Observe the areas of color and tone and use them to give the body its rounded forms, following your knowledge of its structure to derive an understanding of what you can see. Be prepared to use any color or mixture of colors that seems appropriate, in accordance with a close study of your visual impression.

The palette of colors

Rub a new palette with linseed oil to create a good surface. Use a limited range – white, lemon yellow, alizarin crimson and cobalt blue will be all you need. Mix a dark and a light flesh tone with plenty of space to add color variations to the edges of each.

Painting a self-portrait

A self-portrait is a good way to start, giving good practice in painting flesh and hair. For this purpose, worry less about the likeness and concentrate on the tones and colors of the skin. Choosing a composition that closes in on one cheek, for example, might be a good idea.

Setting up a self-portrait

Use a small canvas – as little as 10×8in will do – placed conveniently on the easel. A mirror next to the canvas will provide the image from which you work. Tint the canvas to a light neutral color by rubbing in thinned down lamp black to give a luminous gray.

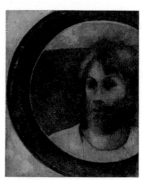

Use a warm underpainting, perhaps sepia, to set the form of the head. Add the principal light and dark flesh tones, then the variations of color you can perceive in the skin.

Clothing in figure painting

Clothes will often occupy more of the canvas than the flesh they reveal. They may have a character of their own which complements and extends the figure subject. First of all, study how they follow the shape of the body – or disguise it. Decide how important you want them to be. They should only be allowed to dominate by conscious intention. Shiny textures, suggested by relatively strong highlights and reflections, or strong patterns, for example, may be distracting. Suggest pattern by the shapes of folded color you see, rather than laboriously copying the design.

1 Begin with the underlying form and sketch in the broad shapes. As anatomy is to the body, so the body is to clothes. At the same time, ample or loose material may fall into independent volumes. Look for hints of color in the shadows, such as the blue beneath the hip, and add it at an early stage.

2 Work over the whole canvas to establish the relationships between the colors of clothing and body. The background is just as important — it too will contribute to the color effect of the complete work. Distinguish the areas of light, middle and dark clearly. They will underpin and define the painting's underlying structure.

3 To introduce folds and texture, work into the areas of tone you have established. Try not to alter the balance you have set, however. Folds and texture work together. The reflected colors in the shadows and the strength of the highlights will show how dense or shiny is the surface of the material you are painting.

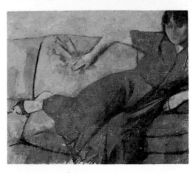

Figure composition

see also pages 35–36

Keep figure compositions simple. Even if you are including several figures, plan the composition so that there is a clear structure, letting the element you consider most important dominate. Decide the direction of the light and use it as a unifying factor, linking the parts of the canvas with lights or darks and using shadows to surround and accentuate important parts of the picture. Choose the range of colors you intend to include, without ignoring the background.

Complex figure paintings

You are unlikely to undertake a project as complicated as Delacroix's *Death of Sardanapalus*, but his methods are worth study. Having decided the subject and the figures to be included, the artist showed an experimental approach, drawing and redrawing the figures in various poses and adjusting and readjusting the composition until he was satisfied. He even changed the viewpoint. The painting shown here is not the finished work but a large oil sketch, showing the artist trying new solutions in the late stages of his work.

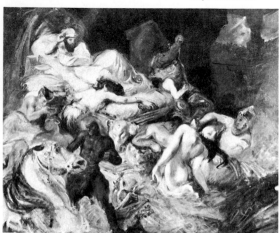

Painting portraits

In theory, a portrait is just like any other painting – it is merely a question of putting down visual appearances accurately. Because the subject is a person, however, special factors have to be kept in mind. First, a physical likeness may prove elusive, and it is easy to become bogged down in a struggle to make the painting look like the sitter. The solution need not be too difficult, however. Just concentrate on what you actually see, establishing the general proportional relationships between the features when drawing. Try working from the center of the face outward, placing each part in turn. Do not be afraid to make alterations, but draw on top rather than rubbing out. You should also try to grasp the personality of the sitter. This may be revealed in the facial expression, but several other factors can help. The posture of the body, the hands, the background and other items appearing in the scene – all can help you suggest what is special about the person you are painting.

Preliminary drawings

Preliminary drawings are important to help you find the pose that suits your intentions best. Try experimenting with both pose and lighting by making bold drawings with the sitter in a number of positions and with the light coming from different directions. Draw in broad tonal areas – you will learn about the sitter as you go along. Do not expect to achieve a perfect and convincing likeness with your first strokes.

1 *Rembrandt van Rijn*
Self-portrait
Even as a young man, the greatest painter of character could look deep into the psychology of the face before him – in this case, his own. Such penetration has only been achieved by a few artists.

2 *Carel Weight*
Portrait of a Girl
In contrast to the austere background used by Rembrandt to focus attention, the artist makes bright materials and flowers part of the composition.

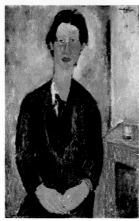

2▼ **1▲**

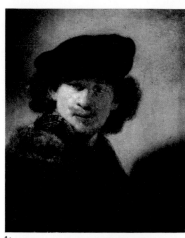

4▼

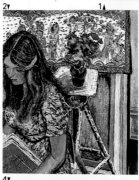

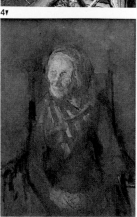

3▲

3 *Amedeo Modigliani*
Chaim Soutine
Modigliani abandoned modeling with light and shade, favoring a highly individual, expressive style. His faces are mask-like, but still recognizable.

4 *Peter Greenham*
Portrait of a Lady
Subtle handling and a simplified color scheme are used in this remarkably perceptive and sympathetic portrait. High finish is not necessary to convey a likeness or express personality.

Selecting a pose
Portraits are likely to take a number of sittings and require concentration from both artist and model. Make sure the sitter is in a comfortable sitting, standing or lying pose at the start. Allow the model to move freely when you are not working on face or hands.

Painting a portrait

You should be prepared to experiment to find what interests you most. In this example, the task is simplified by backlighting. Sketch the general shapes in lightly with brush, marking in some touches of color for reference. Then try to build up the tonal structure, placing the features carefully but without becoming distracted by the smaller forms. Even when refining the work, remember that too close definition of the features may reduce the likeness and look less lifelike.

Scale and distance

There are occasions when you will want to place figures or other objects convincingly in space. Conventional representation is not, of course, necessary – it is up to you to decide how important you want the illusion of space to be. Many artists have concentrated on the picture surface, on the relationships between forms and colors, asserting that representation is a dry and academic preoccupation. If you do want to set objects in space, however, there are several techniques that can help.

Creating depth

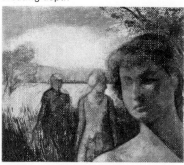

Varying the size of the subject Objects such as figures that are known to be of a similar size will create an illusion of depth if they are painted at different sizes in the same picture. This is a standard perspective effect that can be used quite boldly if you wish to establish several distinct planes in order to lead the eye into the picture.

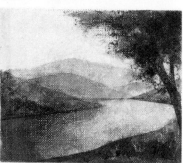

Aerial perspective Because of the effect of air scattering the different wavelengths of light at different rates, objects at a great distance may appear bluish gray. Objects in the middle distance appear more muted in color than those in the foreground. Again, separate planes can be established in the picture in this way.

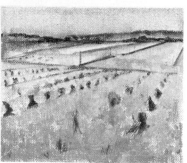

Linear perspective As objects appear smaller with distance, parallel lines that recede into a scene will appear to come together. By including lines of objects in the composition that converge toward a 'vanishing point' on the horizon, a great impression of distance and space can be simply created.

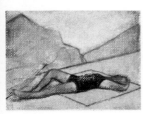

Placing the subject within the picture area can radically affect its importance relative to the other elements in the painting. The center foreground is usually the dominant place. Moving the subject further up the picture also may create an impression that it is further away – even if it is in fact painted to the same size on the canvas.

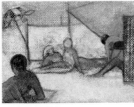

Separate planes Another aid to placing elements satisfactorily in space is to see them as planes, constructing the composition with clearly defined groupings.

Overlapping Objects, including figures, placed in front of or behind each other will suggest depth in the picture. Such arrangements can also unify the composition.

Establishing scale

It is very difficult to judge the intended scale of objects in a picture except by association. Some recognizable shapes are immediately familiar – figures, buildings, animals, for example – and can be used to set not only their own size but also that of other elements placed close to them. Some trees, for instance, could be almost any size, but with a person or a farm animal nearby, it immediately becomes clear whether the tree is large or small. In the same way, if you want to stress the large size of something, place a diminutive figure or building next to it.

This vague shape is obviously intended to represent a rock, but it is difficult to estimate its scale.

Small on the canvas and placed in relation to a large figure, it is clearly no more than a small boulder.

Towering over a full-length figure, it has much greater impact, becoming a major part of the composition.

The sketchbook

Drawings done in the landscape have two purposes: either to make discoveries about the subject you intend to paint, or to provide you with detailed working drawings. These should have color and tonal notes, emphasizing particularly the elements of the composition that you will need to refer to later when you are back home finishing the painting. These can be very useful once you have covered over the initial drawing on the canvas. Take sufficient time over these drawings. While you are exploring your subject you will be subconsciously absorbing a great deal of information. Your sketchbook should represent a visual dictionary, a growing source of reference reflecting all your interests, not simply those things you intend to paint. If you hurry over this stage, or take photographs to be used as short cuts, you will not have learned very much about what you mean to paint and will have nothing to fall back on once the initial stimulation or inspiration has gone. Photographs can represent things unrealistically, isolating and freezing a precise moment. This kind of information has limited use. Regard photographs as a source of reference in conjunction with your sketchbook.

Choosing a sketchbook
The word 'sketchbook' implies something sketchy, but it is said that if four or five marks are meaningful, they can be more value to a painter than his finished work. A pocket-sized, hard-back drawing book should have ample pages so that you will not be over careful with them and be sturdy enough to support the paper as you are drawing. Some have perforated pages and lie flat. Ring-bound books, although they stay open, tend to rub the pencil marks.

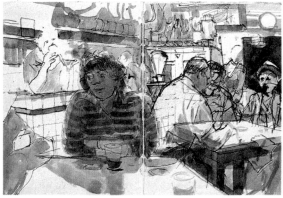

Think of your sketchbook as a double page and draw right across it if necessary. Drawing groups instead of isolated objects will encourage you to think in terms of composition. Draw a rectangle on the page as a compositional frame – the drawing can always grow beyond it if you change your mind.

Making pen and wash drawings

Tone can be suggested with pencil as below or with ink. Using a pen alone, shadows have to be built up with hatching, giving a precise result.

A more free and subtle sketch can be made with washes over the ink outline. Keep the washes to a minimum and match the tones you see.

On top of the wash drawing, the pen can be used again to pick out the deeper shadows. If the wash is wet, these darks will run and look softer.

Sketching outside

 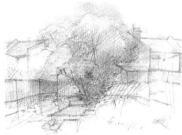

When you arrive at the spot where you would like to paint, a lot of time can be wasted looking for the ideal view. Sit down and get to work, investigating the various possibilities in numerous pencil sketches. Then single out one or two viewpoints that particularly appeal to you and do a really thorough drawing of the composition. Ask yourself what features it has that attract you and draw small studies of these as well. Include as much detail as you will need for completing the painting at home, and make sure the drawings do give you that information. You may be intrigued by the interplay of different shapes, the silhouettes of trees and buildings or by the tonal contrasts.

Tonal range in a landscape

Tones are particularly important to note and you should check that these remain consistent across the canvas. Notice right at the beginning where the tonal scale falls – is the picture in a high or low key or are the tones all in the middle range, such as in the painting by Sisley on page 49? In a landscape there is usually nothing very white or very black. In direct sunlight, shadows may be deep, but they are unlikely to be as dark as they first appear. Light is usually diffused by haze or cloud, although storms are exceptional, giving strong contrast.

The eye is attracted by the lightest thing in a picture or the place of most contrast. Keep the lightest area small and within the rectangle, not drifting off to the edge. The real darks should also be small. Be aware of the similarities and contrasts between tonal areas and the richness and variety to be achieved by the arrangement of these light, dark and middle tones.

Many different, and often ingenious, methods have been evolved to make notations of color and tone in a landscape. Some artists cover their drawings with written notes, although you may find that words on a small drawing can sometimes confuse the tones. Other painters make a dot in the center of the area of color, then draw a swift line from it to the outside edge where they make their notes. Some use series of dots which act as reminders. You will have to feel your way until you have a system that works for you and becomes a personal shorthand, a code that trips your memory of the scene. However, it will be of no use at all if you are not able to read it back.

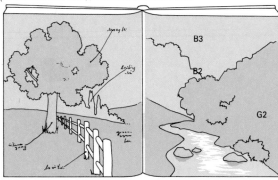

You can record color as written notes by association – for instance, noting that an area of sky is 'pearly gray' or 'lemon yellow' or that it matches the color of your blue sweater. Or you might prefer to write down the actual names of the pigments, such as 'burnt sienna with a touch of ultramarine'. Try to be as accurate as you can.

Another method is to use a numbering system that denotes the relative values of the colors. Thus, , B1 (blue 1) would represent the brightest blue and B5 would signify just a hint of blue. You should also indicate on your drawing the modulation of the colors in the scene. Changing colors could be noted with an arrow.

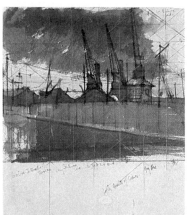

Ken Howard
Dockland Sketch
An example from a contemporary artist's sketchbook shows his individual method of noting, both visually and in words, the main characteristics of a scene. Working in diluted ink with pen and brush, he concentrates on the structure of the scene, using notes together with a grid pattern to relate the shapes and positions of the various elements that interest him for a future painting.

Interpreting the landscape

Few subjects appeal more to the painter than landscape. It is important, however, to go beyond the straightforward presentation of an attractive scene – something picture postcards can do quite adequately. Instead, train your eye to recognize the pictorial possibilities in unlikely places such as industrial areas, in details and in unusual lighting conditions. More than anything else, try to discover the rhythms of line, the vibrations of color, and the structures of mass and tone that the appearance of nature offers to the artist.

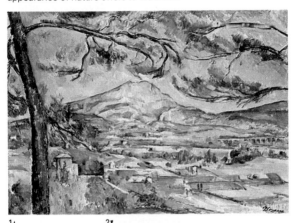

1▲
Cézanne did more than any other artist to show the pictorial qualities of nature, particularly in his numerous studies of Mont Sainte Victoire 1. While still clearly representing the scene, the picture is in fact a symphony of color harmonies and linear rhythms. Ken Howard's beach scene 2 shows an additional development in the choice of a mundane and unpromising view which in the end expresses a sense of the place far more than a conventional panorama. Marc Winer 3 here concentrates on the patterns and harmonies of foliage reflected in water. The figure sets the scale of the view.

2▼

3▼

Painting landscapes

Keep your materials to a minimum as you will probably have to carry them from the car or closest transport to the location. You may find that painting on either a primed toned board or colored cardboard is more practical than canvas, which can be damaged. You can start and finish the picture anywhere on a panel and it can be trimmed up or centered later. Oil-painting paper can be tacked to composition board. You could also take just one stretcher with several pieces of canvas, temporarily attached with thumbtacks, then stretched when you return home.

Do not be too ambitious. Start too large and you may be unable to finish if you are intending to paint the whole picture in one layer. Filbert-shaped brushes in sizes 4, 5 and 6 will cover the canvas quickly. It is often a temptation to pick up your brush too early, thereby making mistakes on the canvas. The time spent drawing is very valuable and allows you the chance to make discoveries. Nothing in a landscape stands still; the time of day and the weather will dictate how quickly you will have to work.

Working to a time limit

dawn

midday

dusk

Ask yourself, how much time do I have and what can I achieve in that time? As the weather and the light are altering every few minutes, you have two choices: either to capture a fleeting impression in an oil sketch, or to start something on the spot, perhaps to be completed at home.

During the early morning and evening hours the scene will change rapidly – within an hour four or five different compositions may pass in front of your canvas. In the middle of the day things will not vary as much and you will be able to spend more time on one canvas. You should reckon on having about 15 minutes close to dawn, 30 minutes in the early morning, two hours at midday and about 15 minutes again in the evening. Early or late in the day, decrease the size of the canvas. In the middle of the day the size can grow. As soon as the view changes, change the canvas rather than the composition, and go on with the first picture next day.

Selecting the subject

Frame up the view with your hands or use a rectangular cardboard window. Think about scale: do not try to cram a panorama onto a small panel or fill a large canvas with a small motif or too many tiny forms. Avoid over-pretty subjects.

If you take in an angle of view of more than 60 degrees you will have to scan, and then cannot judge perspective accurately. A narrower view will quite often strengthen the composition by emphasizing the individuality of each shape. For example, if there are 20 trees in your wide view, they will not only look similar but appear so in the picture. Pick out two or three and suddenly there will be a much sharper contrast in their shapes, scale and detail.

Response to the subject matter

What is it that affects you emotionally about this particular bit of the landscape? Is it to be a painting where the eye 'reads' or moves across the canvas in an anecdotal way, or is it to be a picture with a strong focal point?

Start by isolating the area you are going to paint and thinking about the proportion and scale of it. Select a piece of board or a canvas suitable for the shape of that idea. Pin the relevant drawings up on your easel or painting-box lid to remind yourself of the wide scope of your chosen subject because, as your tempo changes from excited response to serious, organized painting, you may lose the feel for the whole composition. Finally, lay out your palette in the normal way.

How to start

Some painters like working in a high key on a white surface, but the whiteness of the canvas can actually be very glaring in strong sun. Speed is important in the field and here a toned ground has its advantages. Almost any color will tone the ground, or use a general color from the composition and apply it with a rag, a housepainting brush or a large bristle brush. The paint should be thinned down with turpentine to cover the whole canvas, dealing with the main areas of color and tone together. This will dry quickly. Or, without any added thinner, lay the underpaint over the canvas, scrubbing it in with a vigorous brush movement or a rag. Once that is done, you can either begin to develop the geometry and rhythms of the scene in a linear way, or concentrate on larger areas. In a one-off painting there is usually no time for over-painting in layers and thick 'fat' paint can soon get into a sticky mess, so you will have to scrape down the surface.

A dark, glowing stain can be achieved by applying thick paint and rubbing it off with a rag, and is more powerful than brushing on thinned paint.

Laying in thick paint with a palette knife straight onto the primed canvas covers the surface quickly and is good for covering large areas.

Where to start your painting

If you think about working from dark to light you will not necessarily begin with things furthest away, such as sky. Establish the dark mass of trees, then build the sky up and into them, varying the edge and avoiding harsh, scratchy lines on top of the light sky. Leave highlights, such as the foreground tree, for later.

Quick oil sketches

With quick sketches, do not try to take in too much. Work to a small scale – a small board such as 6×8in will be sufficient. Even with a more elaborate two-hour sketch, limit the size to 20×24in. In this case, work in the middle of the day, when the light changes will be slower.

15-minute sketch

1 Use the rapid sketch as a means of recording a first impression and opening up your technique with oil paint. Try using a rag, Q-tips or your finger, working the sketch in one layer.

2 As you develop the sketch, do not be distracted from the aspects of the scene that first attracted you. If your ideas change about the approach to the subject, put up a new canvas and start afresh.

Two-hour sketch

1

2

3

4

With a more finished sketch, relatively complex compositions can be taken on. Following the approach taken here, 1 identify and set down the most prominent areas of pure color as a series of small touches. 2 Then add the other tones, relating them to the keys you have already established. 3 If the original idea becomes lost as you work, scrape down the thick paint, leaving only the impression of the colors. 4 The final sketch can then be built up from this base.

Color in landscape

Look at the most obvious colors in a landscape, green and blue, and compare them. How blue is the sky? How green is the hedge? How yellow is the meadow? These local colors must be made to fit into the tonal scheme of the whole picture. Green is a particularly dangerous color, and landscapes are often full of it. It is possibly the most difficult color to use over large areas and needs to be tempered with other colors as well as contrasting warm and cool greens to keep them lively and singing. Your paintings will be much more convincing if you avoid the commercial 'sap greens' and 'grass greens' and mix your own from lemon yellow, yellow ocher, cobalt and ultramarine, where necessary adding some red or possibly a bit of black. If you do not attempt to do this you will find yourself using the same green everywhere and the end result will be dull and unrealistic.

Green: the color range

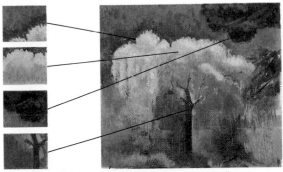

Green fields in the foreground become increasingly blue in the distance because of the effects of aerial perspective (p94). As a result, you can expect to see the strongest greens in the foreground. What you think should be a green tree on a distant hill may not be green at all in comparison to the field at your feet, but brown or gray or blue. Look at the green label on the paint tube or the blob of paint on the palette and ask yourself: Is that field really the same green?

Skies and clouds

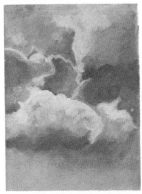

The light and color in a landscape are entirely dependent on what is going on in the sky. They could be said to be a direct reflection of it. Skies are not all white, gray and blue. Some are also pink, yellow, green and violet. You will notice that the sky is not the same color at the top as at the bottom and also differs from left to right, depending on where the sun is. Clouds are ethereal, constantly changing shape across the expanse of sky. Aim to capture their colors correctly rather than accurately reproducing their shapes. Clouds are rarely pure white. Naples yellow may prove a useful color for the warmer areas in clouds.

Trees and foliage

Trees should be painted as vital, living things rather than masses of limp cotton wool. In winter they form powerful shapes. If you paint a dark tree on top of a light sky, are you simply following a preconceived notion of a tree? If you paint the tree first and then the sky up against it, you will be conscious of the negative shapes around the form, in fact you will redraw the tree and really observe it much more intently. Consider the branches and the tree's distinguishing shape. Where the sky is visible through a tree in full leaf it should be treated with great care – these shapes make the tree look realistic. Detailed drawings of leaves, branches and bark are useful for later reference. Wood is not a uniform brown but ranges from gray-green to pinky brown. Its color needs special care – it is impossible to show it convincingly with brown pigment straight from the tube.

Tree forms

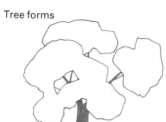

Do not dismiss trees with a vague outline nor paint every leaf painstakingly. See them as a sculpture of solid forms – it is impossible to see individual leaves except at the edge or in close-up. Note, also, the proportions of the trunk.

Painting trees

In summer, groups of leafy trees, as well as grasses and bushes or individual clumps of leaves, can be defined on the canvas as masses divided into dark and light by the sunlight. Do not paint the visible branches evenly silhouetted. Choose one and follow it to the tip of the branch, making sure that it neither looks lifeless nor scratchy.

Building the picture

A complex landscape worked on over several sessions is more dependent on a firm structure of shapes, rhythms and tones than on capturing the transitory moment. First, you should keep a constant watch on the original drawing. The eye is often pulled to the lightest spot, the brightest color or where there is an area of most contrast or activity. Make sure that their importance or emphasis has not been lost. Second, find a key point in your composition to refer back to. This will keep your drawing and painting accurate and true to your first idea. Third, do not be afraid to restate or redraw as you progress. After a day's painting take your work home and scrape it down if it is sticky, put it up where you can see it and study it carefully. Sometimes it is helpful to turn it around and leave it for a week. Later, you can often see where it has gone wrong and will be able to work on it with a fresh approach.

Painting sky and clouds

Clouds should not be left to the end but worked on as an integral part of the picture. Identify the broad shapes and try to relate these to the lower part of the picture to add compositional unity to the landscape.

Finishing touches

With the major areas of color and tone laid down, decide how much finish you intend the picture to have. It is easy to spoil your work by laboring over details. Instead, look for the highlights, even a tiny speck of light as the sun catches the underside of a leaf. You may also want to deepen some shadows to enhance the tonal range.

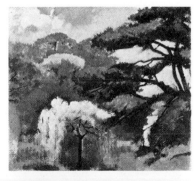

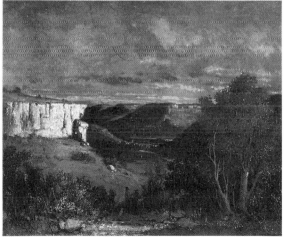

Gustave Courbet The Valley of the Loue
One of the finest landscape painters, although better known for figure compositions, Courbet painted many scenes in the countryside he knew best in southeastern France. His understanding of the way the light breaks through the gathering storm clouds and lights the cliffs is remarkable.

Seascape

The sea offers a superb subject for paintings. The sense it gives of the vast scale of nature and the drama of its moods have inspired artists for centuries. The shore is the best place to find suitable views with the sea meeting the land in sweeping beaches, windswept dunes or high cliffs. Although the sea can be violent, the broad horizon and even expanses of water and sky more often have a soothing effect, and the subject matter can be interpreted in many ways, even as abstract patterns.

Water: ripples and reflections

Study the rhythm of ripples. Although widely spaced in the foreground, they close up in the distance. See how the larger patterns make smaller shapes, rounded to suggest liquid form.

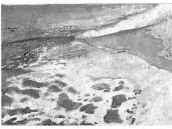

Where land and sea meet is often the point of most activity. As the tides rise and fall, there may be overlapping ripples on the shore, tidal pools, breakers crashing against the rocks, or simply a change from light to dark.

Reflections can be bright or subtle patterns of color – an upside-down view of the scene.

Painting a seascape

1 Spend some time selecting a view and sketching; then choose a canvas. Start with the basic division of the horizon – sea against sky. First decide where your greatest interest lies. Is it in the water, the sky, or the color and activity on the beach? Sometimes it is not in the foreground at all but on the horizon. Now rub in the main tonal areas.

2 The sea is like a fragmented mirror reflecting all that is going on in the sky and so it must bear some relation to it. As it is a vast area that changes all the time, you must be prepared to paint quickly. Build up broad areas over the water, the sky and the land, relating colors across the canvas and establishing the tonal range.

3 The color and brightness of the water depends on its clarity – river water seldom has the same sparkle as the sea – and on the quality of the light. Here the white ground gives a high-key luminosity. Look out for the marvelous contrast between the local color of the tiled roofs, boats, deckchairs and bathing suits and the subtle colors of nature.

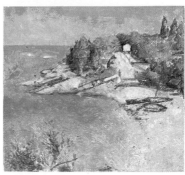

Drawn and painted studies

Boats consist of a series of curves which are difficult to paint. One way to overcome this is to build them up by referring to the shapes on either side of them. Think beyond trying to portray the actual structure of boats. They will be more convincing if painted simply in terms of shape, color and curves to create pattern.

Salt water and sea shore are a rich source of study material, from shells to marine plants. If you cannot get to the coast, you could visit a local fish store or aquarium.

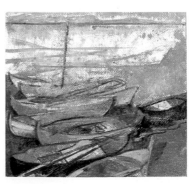

Towns and buildings

The sketchbook really comes into its own with townscapes. It is quite possible to work direct, sitting in a street or a café, paintbox on knee, but here you will encounter one of the drawbacks. Who has not, at some time or another, peered over an artist's shoulder? Being the center of such interest can be very distracting. One answer is to make detailed drawings with full notes surreptitiously behind a newspaper or in a small sketchbook, and complete the painting later in relative privacy.

Eye level and scale

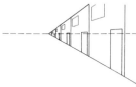

Eye level simply means the line which is the same height above the ground as your eye. The horizon, when you can see it, is always on your eye level. If you take a building and draw lines from top and base to meet at the horizon, the relative scale of other buildings can be judged.

Buildings

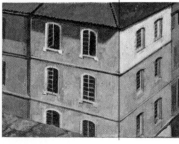

Depending on the style in which you paint, you can include as much or as little architectural detail as you want. In any case, look for the essential shapes of the buildings, putting down their solid forms before moving to incidental details of windows and doors. Identifying and plotting in the main vertical right down the canvas, whether it goes that far or not, helps you to see how things fall under one another. In a hot climate, note the direction of the sun and place yourself so that it is at your back for as long as possible, or so that you are in the shade. Shadows are important to the composition as well. Diagonal ones can divide the space, link up shapes and allow you to introduce changes of tone from light to dark. You will be unwise to tackle over-elaborate compositions. Look instead for bold and interesting shapes.

Judging angles

Whether they are above or below you, the top and bottom of any flat vertical surface, such as a building, remain horizontal so long as they are exactly opposite you. When a building is turned from you it becomes subject to perspective. To judge its angles, imagine a clock face centred on the intersection of the angle. You can 'read' it, as you would the time.

Bernard Dunstan
Campo S. Maria
Formosa: Dusk
As the twilight sets in, dark tones look rich and soft. The people in the scene provide light accents against the warm grays of the stones and paving. Evening paintings often rely on the use of a general tone that is rubbed in, with 'fat' paint on top delineating the figures to give an atmospheric effect.

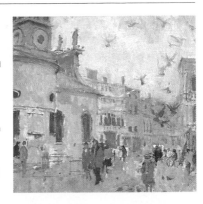

Figures in space

If you stand up or sit down, the eye level in the scene goes up and down too. If you are standing, the heads of figures far or near will all be on a level with your eye and also with the horizon. If you sit and remain standing, your eye level will be at their waist levels, which will appear to remain constant

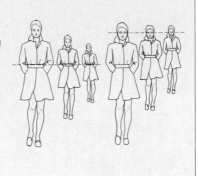

Starting to paint

First of all, choose a vertical or horizontal format. The latter is more suited to broad views including a distant horizon, the former to pictures at street level with the buildings leading the eye up and down. The foreground is important in townscapes – try to use the incidents which naturally occur there in your composition, and do not let the background dominate.

First identify the main blocks made up by the buildings and construct a framework of directional lines to define the main perspective. Here, the buildings follow the rise of a hill, so the point at which the main perspective lines converge is above the horizon.

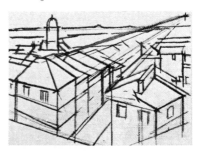

Building tone into the painting

Having plotted in your linear drawing, or simply indicated a few verticals and the eye level, brush or rub in the main areas of tone in 'lean' paint. Mineral spirit dries faster than turpentine. Mass in the shapes without hard edges at this stage. Define light and dark planes before adding detail.

In warm weather, thin tonal lay-in will take about an hour or so to dry. If in a hurry, you can work directly on to the wet paint, but, when one area of paint has to be put down beside another color that is still wet, it is likely that they will mix together and look muddy. If light paint goes into a dark area by mistake, it can be covered over quite easily. It is a little more difficult in reverse. The following day, however, the first layer of paint will be dry and you can build on top with 'fat' paint.

Street signs and other lettering

Whether letters are painted clearly or only hinted at depends on the type of painting, but they can provide a good focus of interest. Look at lettering as shapes rather than words, painting them from the bottom to the top in an attempt to suppress your own calligraphic style.

110

Reflections in glass and water

A reflection in a window can be gradually painted from the inside to the outside edge. Shadows will obscure parts of the image. A car can be seen as a box of reflections in which you can see yourself, a person walking past, another car or the houses across the street.

Reflections in the rain will be less well defined. Colors may be restricted to grays and browns, making the vivid colors of umbrellas and clothing stand out. These provide attractive shapes and silhouettes, both in full view and reflected from the wet streets.

City colors

Each city or town will tend to have its own characteristic colors, depending on the local building materials and the climate and type of vegetation.

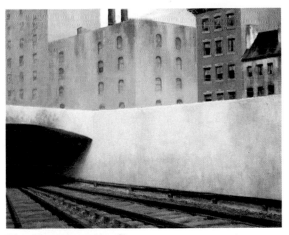

Edward Hopper Approaching a City
Even a drab, run-down part of the city can produce powerful images in the hands of a great artist. Note the single accent of the red stop light.

Movement

All paintings include formal or abstract elements – the two-dimensional surface of a painting can be seen purely as areas of color and tone if you close your mind to the objects, people or landscapes they represent. Very often, the non-figurative aspects of the painting (the shapes and colors) combine with the subject represented to reinforce its impact.

Movement is one of these elements. It need not imply a moving subject in the painting, for the lines and spaces between shapes can set up independent rhythms, leading the eye around the picture. The movement can be harmonious and gradual, or it can be agitated and anxiety provoking. It can be sensuous in its curves or solemn in its regularly spaced masses. It can be an end in itself, giving pleasure through its abstract qualities, or it can echo the mood of the subject.

Linear rhythms

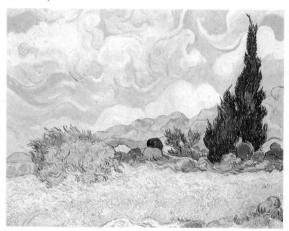

Vincent van Gogh
Cornfield and Cypress
Trees
The surface of van Gogh's picture is a swirling complexity of rhythms. The cloud forms loop and curve, the cypress trees shimmer and the corn is painted in stabs of color with an undulating pattern. The effect strongly suggests the stiff breeze running through the scene, but also conveys the artist's experience of his own inner tension.

Sketchbook exercise

As an exercise, choose a picture with the complex surface patterns and sense of movement of the van Gogh and draw the patterns you see – without attempting to copy its subject.

Intervals
Philip Wilson Steer
The Bridge

At first sight, this picture could hardly be simpler – uncontrived and closely observed. But the way the shapes are placed on the canvas is just as important as the sharpness of Steer's eye. The intervals or spacing of the objects give the picture its quiet rhythms. Note how three main verticals on the right form a descending sequence and how the boats make a broken line of shapes. Again, try sketching a simple picture like this to identify the main shapes and the patterns that are formed by their scattering across the surface of the picture.

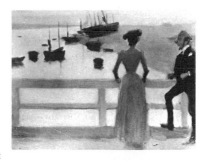

Broad rhythms
Marc Chagall
Bouquet with Flying Lovers

Chagall's dream-like paintings often have objects floating weightlessly in space. Here, the movement is circular, with the whole picture forming a slowly moving vortex, increasing the sense of strangeness.

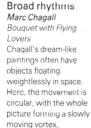

A sketch to study such major movements (left) should concentrate on the directions of the flow.

113

Space

Pictorial space can be handled in very different ways, and once again it can have considerable effects on the impact of a painting. For some artists, the creation of a convincing illusion is the aim – they construct a real-looking space so that the spectator will become involved in the scene. Other artists deliberately compress or distort space to focus attention on elements of major interest. Some artists feel free to dispense with the illusion of space altogether, concentrating on the abstract and non-representational aspects of the picture. Remember that space, or the lack of it, can be manipulated in your paintings for specific effects.

Compressed space

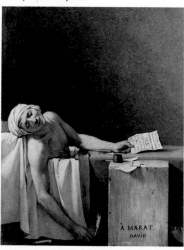

Jacques-Louis David
The Death of Marat
David's requiem to the revolutionary leader assassinated in his bath is intensely moving, arousing our sympathy with the subject. Among the devices used by the artist is a very shallow space with a large expanse of plain background. The result is austere, with no distraction from the tragic figure of Marat. In fact, the whole picture only occupies two planes, the foreground occupied by Marat lying in his bath and the bare wall placed immediately behind.

Analysing space in a painting

Making drawings of works of art teaches a great deal about the decisions the artist reached when placing the subjects. Concentrate on the planes in the scene.

You could also try changing the basic composition, here raising the figure in the picture space, thus making it more dominant. See how the impact is reduced.

Even more radical alterations, changing the angle from which the subject is viewed, produce an interesting image – but one that lacks the final dignity of the original.

Unlimited space

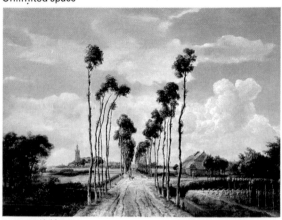

Meindert Hobbema
The Avenue at Middelharnis
This landscape is an outstanding example of unconfined space in a picture. It is so natural that we might expect to look up and see its sky continuing. The sense of depth is created by the perspective of the trees leading the eye back through clearly defined planes (see sketch).

The rejection of space
Pablo Picasso
Daniel Henry Kahnweiler
In the early twentieth century, the Cubists began to break up objects into facets and angles. They were thus asserting the reality of the picture surface as opposed to illusionary space. Picasso's portrait of an art dealer is still recognizably human – it even has hints of a likeness in the simplified features – so it is not a purely abstract painting. It has no real space, however. Its surface has great interest without the literal representation of recognizable solid forms.

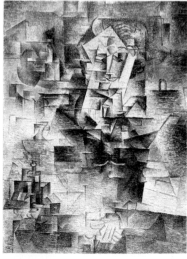

Mood and expression

The mood of a picture owes much to the subject painted, but it is also helped by other factors, such as the shapes and colors within it. Some remarkable paintings radiate a particular mood so strongly that it is difficult to resist their emotional message – whether it be excitement, calm, anguish or joy. The contribution of color is discussed on page 125. Shape can also have an effect. It is not easy to pin down the underlying psychology, but it does seem that certain arrangements and structures have related emotional responses. Broad, massive shapes, for example, suggest weight and quiet, whereas sharp angles and elongated shapes are arousing and imply tension.

Anxiety and inner calm

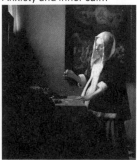

Jan Vermeer Woman Holding a Balance
Vermeer's paintings have an unequalled sense of calm. They are small and simple, but it is very easy to be drawn into their private and timeless world. The solid mass of the forms helps establish the stillness and silence of the scene, emphasized by the entirely realistic treatment of the hazy light. Try an analytical sketch of this picture and the Munch below in order to understand the very different approaches of the two artists.

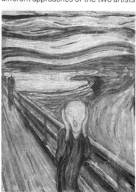

Edvard Munch The Scream
Munch, the most neurotic of artists, actually experienced this 'scream piercing nature'. The swirling lines with their constant, fluid movement are very unsettling, communicating the artist's nameless terror.

Edward Hopper Automat 1927

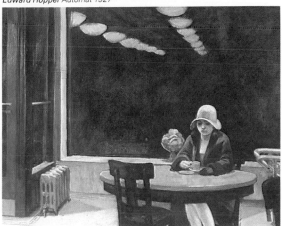

Hopper's paintings have come to symbolize the loneliness of city life, although
they are rarely depressing. In this example, several aspects of the composition
increase the sense of the girl's isolation in the busy city. First, she is small in
the picture space, yet still dominates it because there are no distracting
elements. In addition, the large expanse of mirror, reflecting lights but no other
people in the room, surrounds her and implies the emptiness of her immediate
and also more general surroundings.

Pablo Picasso
Three Dancers
The nightmarish figures
of Picasso's frenzied
dance are charged with
wild abandon. The
picture is full of sharp
angles and jagged
edges, all calculated to
add to the sense of fear
and unease the painting
is deliberately intended
to arouse.

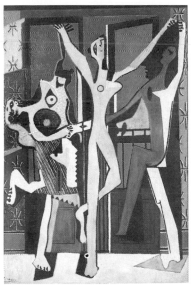

Painting animals

Animals have such energy and life, their actions are so varied and dynamic, that they make excellent subjects for paintings. Their shapes also tend to be more simple than the human form, encouraging strong compositions and bold execution.

Preliminary sketches

Domestic animals Thorough sketching is the key to painting an animal successfully. Pets are good to start on. They make good models as their movements are predictable, allowing regular occasions for study. These preliminary sketches were done in pastel pencil.

Wild animals cause greater problems. It is just as necessary to understand their movements fully, but the opportunities for close study are few. Zoos offer one approach, but while some zoo animals behave naturally, others seem lethargic and depressed. In some cases, you can work in the field, making rapid sketches with the aid of binoculars. You may also consider using photographs as reference. Always make a thorough study of several photographs to gain a full understanding rather than copying from one source.

Composition, shape and texture

It is tempting to take a literal approach when painting animals. Their behavior is so immediately appealing that just producing a colored representation may seem a sufficient goal. It is important, however, to remember important compositional elements – even for a straightforward animal portrait. Think, for example, of the areas of canvas that the subject animals will not occupy. In other words, consider the negative shapes around the subject. With a successful pictorial structure, the elements of the composition will fall into place. Textures may also have a major role. Look carefully to see how the light is absorbed by and reflects off the unfamiliar surfaces of fur and feathers. Shiny coats will reflect many interesting colors. Ignore your preconceptions – an elephant, for example, is more likely to be brown than gray – and concentrate on what you actually see.

For complex animal compositions, be prepared for a number of preliminary drawings. By studying the cows for this spring scene, Marc Winer was able to arrange them into a semicircular arc quite convincingly, with the front cow occupying the foreground plane and the others leading the eye back into the picture. The outline diagram shows, however, the picture relies just as much on its two-dimensional design, with the dark areas occupied by the cows balanced by the lighter areas of varied grass, muted sky and pink blossom. The naturalness of the scene is unaffected, however.

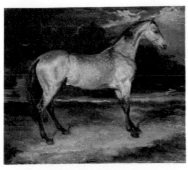

Théodore Géricault
Horse Frightened by Lightning
The nervous energy of highly strung horses fascinated Géricault. This quivering animal, transfixed by fear in the eerie light of an electrical storm, was intended by the artist to convey the subject's tension and excitement to the viewer of the painting.

Animals in a landscape

1 It is unlikely that you will be able to paint wild animals as you watch them, so work from drawings. Concentrate on relating the animals to their environment in a natural way. Outline the main elements of the landscape first and then add the animals as the main focus of interest, perhaps dominating the foreground and ideally forming an integral part of the composition.

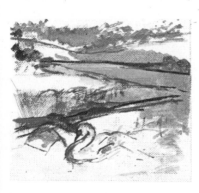

2 Work on both animals and landscape at the same time to ensure the unity of the composition. Build up the main areas of color and tone with thin washes of paint to start with, defining the shapes of the animals and also the negative shapes of the landscape around them. Broadly establish the color and tonal range of the scene.

Textures of fur, feathers and scales

Fur can be imitated with a hatching of lines painted with a fine brush. Dry paint on top will suggest a downy quality.

A loose working of light into dark and dark into light can build up an effect of short, thick hair over a complex surface.

For long, smooth hair, define more generous areas of color and tone, with occasional lines to suggest the rhythms of its fall.

3 The swans in this painting pose some interesting problems in handling color and light. They will not appear as uniformly white as expected and the reflected colors in the shadow areas will include rich blues and violets. Be prepared to simplify the shadows and highlights to build up an effective modeling of the three-dimensional shapes before you.

4 As the focal point of the picture, the swans should receive more attention, with the highlights strongly accented. The other main area of interest is the bank of reeds behind them. Finally, adjust the main lights and darks to unify the lighting and atmosphere of the scene, ensuring that the birds are lit in the same way as the landscape.

Individual feathers are rarely visible except for the large flight feathers on wings. Identify the main areas of light and shadow, and use loose dabbings of dry paint to suggest a downy texture.

The scales of fish and reptiles require you to define the general rounding of the forms more positively. Suggest only a few individual scales and show reflections and sharp highlights.

Color interaction

No color exists in isolation. In nature and in a painting it will be affected by the other colors adjacent to it. Even a relatively dull ocher may appear bright yellow if surrounded by deep blue. These interactions between colors, producing harmonious or discordant effects, can be used to great effect.

Color and light
The color of objects can be affected by the light falling on it. Thus, the reddish sunshine of late evening will bathe a landscape in its warm glow, and all the colors in the scene will reflect this to some extent.

Claude Monet
The Haystacks
Monet was fascinated by the play of light on landscape. He painted some subjects several times over, at different times of day and in different weather conditions. These haystacks, for example, change entirely from mid-afternoon to late evening. With the sun high and the sky blue, the light is cool, and blue can be seen in almost every part of the scene, especially the shadows. Later, however, warm reds and pinks from the setting sun predominate.

Simple harmonies

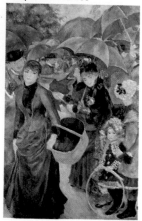

Some of the most effective pictures are painted in a very limited palette, with a single color or a closely related group of colors covering much of the picture surface. Try using subtle variations on single color themes – you will be surprised at the wide range of possibilities you will be able to find.

Pierre Auguste Renoir The Umbrellas
In this picture, almost all the crowded figures are wearing black – yet the artist used no black paint. Instead, he created a delightful harmony of blues and browns which convincingly suggests the various black materials. Occasional touches of brighter blue, such as in the jacket of the central woman, enliven the effect.

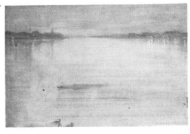

James McNeill Whistler
Nocturne in Blue and
Silver
Whistler's view of the
Thames is almost
monochrome – a soft
variation of bluey
greens and grays. The
delicate pale orange
of the lights provides
the only relief in the
severe harmony.

Contrast and harmony

For some artists the relationships between colors are a subject in their own right. Colors close to each other on the color wheel (see p46) harmonize, while those opposite will set up a discordant effect. Lightening colors to a similar degree will also bring them into a harmonious relationship. Compose your paintings with these effects in mind.

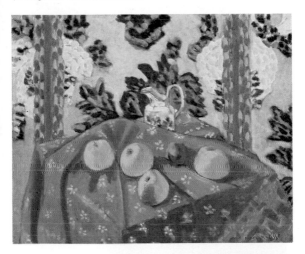

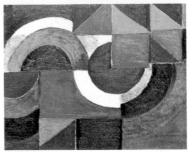

Henri Matisse
Apples on a Pink Cloth
The two predominant
colors are pink and blue,
harmonizing as they are
close on the color
wheel.

Sonia Delaunay
Color Rhythm
Here the colors are
more vibrant, with the
artist exploiting the
contrasts.

Limited palette

Unlimited palette

A common mistake, particularly among beginners, is to use large numbers of pigments in every painting. It is possible or even desirable, however, to work with a limited number of colors, thus containing the range of hues within the painting. At other times, a wide range of pure colors may be used for a more varied and chromatic effect. Several limited and unlimited palettes are suggested below – try experimenting with them.

Classical palette

1 lamp black, 2 flake white, 3 yellow ocher, 4 venetian red, 5 terra verte. This palette, consisting of earth colors, offers great tonal range and a satisfyingly restrained harmony. Try using it for a small still life.

Cool palette

1 titanium white, 2 cerulean blue, 3 cobalt blue, 4 ultramarine, 5 (cadmium yellow), 6 (cadmium red). Here, the effect will be cool, but with two warm colors added (5 and 6) an enormous range is possible.

Warm palette

1 titanium white, 2 yellow ocher, 3 cadmium yellow, 4 raw sienna, 5 cadmium red, 6 (cobalt blue). This warm palette is ideal for sunny landscapes. The cool blue makes it possible to match most colors.

Warm to cool palette

This palette runs from light to dark in two directions: warm and cool. It includes a full range of colors, and sections of the scene can be identified as lying within the warm or the cool range. 1 flake white. Warm: 2 Naples yellow, 3 yellow ocher, 4 cadmium yellow, 5 raw sienna, 6 chrome orange, 7 scarlet lake, 8 burnt umber. Cool: 9 lemon yellow, 10 emerald green, 11 viridian, 12 alizarin crimson, 13 cobalt blue, 14 ultramarine, 15 cobalt violet, 16 raw umber. 17 lamp black.

Chromatic palette

Here, for a rich and vivid effect, 'synthetic' colors are used, to the exclusion of the earth colors. The effect is of the pure colors of light rather than the muted hues of nature.

1 titanium white, 2 lemon yellow, 3 cadmium yellow deep, 4 chrome orange, 5 vermilion, 6 cadmium red, 7 alizarin crimson, 8 ultramarine, 9 cerulean blue, 10 cobalt blue, 11 cobalt violet.

Color psychology

Whether in nature or in paintings, colors seem to have direct effects on mood and can even arouse quite strong emotional responses It is difficult to be precise about such questions – individuals vary considerably and a color that means one thing to one person may mean something quite different to another. In addition, such responses may be to a great extent cultural and will vary with a person's background and upbringing. Some paintings are well known to communicate exuberance or sadness, grandeur or sensuous enjoyment, however, largely through the colors in which they are painted. Titian and other Venetian painters, for example, used strong and vibrant colors, suggesting intense joy in the splendor of the world. Picasso's transition from his 'Blue' to his 'Rose' period marked a strong shift in the mood of the paintings, from the melancholy of blue to the nostalgia and romance of pink. No theory has fully explained these effects of color, but the comments below may give you pointers in the use of color to achieve a desired response.

Goethe's color triangle

Goethe used this triangle to explain his theory of color and emotion. Colors on the left edge are exciting, while those on the right are serious and calm. The four colors at the top suggest strength and power. Those nearest the left corner are serene and those at the right corner are melancholy. In general, this system seems to correspond closely with the use of colors in art.

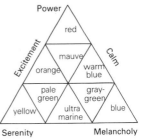

Color	Association	Emotional response
Black and white	Light and dark, good and evil.	Pure whites and blacks are cold and uninviting. Grays can be restful.
Red and orange	Fire, sunsets, danger signs.	Excitement and intense activity. Red is nature's warning color.
Yellow	Fire, sunshine, flowers.	Provocative and energetic, yellows are cheerful and stimulating.
Earth colors: browns, ochers	The soil, rock, wood and bark.	Warmth and cheer. Invigorating if strong, soothing if lightened.
Green	Growing plants, natural landscape.	Peace and simplicity. Freshness and growth. Nostalgic when mellow.
Blue	Sky, water, space.	Deep blues suggest mystery. Paler blue becomes cold and melancholic.
Violet	Rich velvets, splendor.	Sense of dignity and deep calm. Can be threatening.
Pinks	Rich cloths, bright flowers.	Strong pinks can be sensuous, even erotic. Suggest luxury.

The examples on these pages show how some artists have used color to increase the emotional impact of a painting. Some of the paintings are representational, some are abstract. In a sense, none are truly abstract, because they convey the artists' ideas just as clearly as if they had portrayed a recognizable subject. In most cases, the color range is limited, with the effect relying on the power of a large expanse of color.

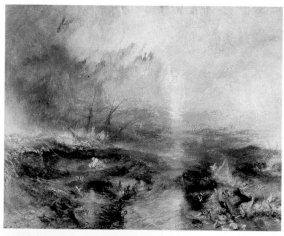

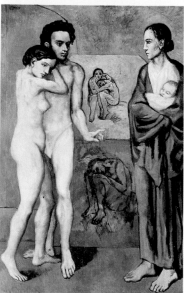

J.M.W. Turner
The Slave Ship
Turner was influenced by Goethe's color theory (see p125). In painting a horrific incident in which slaves were thrown overboard from a ship, he used the power of rich reds and yellows to suggest the cataclysmic excitement of the event. Even the sea is blood red.

Pablo Picasso
La Vie
Picasso's mysterious painting from his Blue Period uses a similarly simplified color scheme for a contrary emotional effect. The combination of dull blues and grays suggests melancholy to the point of despair.

The expressive power of color combinations

Colors used together can also have strong emotional effects. Although this has been used by artists intuitively in the past, during the twentieth century it has become a conscious dictum, especially among Expressionist and Surrealist artists. For the full effect of such works, visit art museums – the large scale of some paintings is important.

Emil Nolde
The Sea B
Nolde's brooding sea pictures achieve an almost frightening atmosphere by their use of heightened colors that still reflect those to be found in nature. Deep blue, purple and yellow set up a violent and threatening contrast.

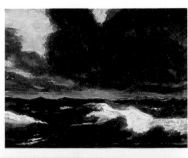

Mark Rothko Black on Maroon
Rothko's huge canvas is almost funereal in its deep, sonorous color combination and projects a profound sense of tragedy.

Joan Miró
Painting 1927
Unlike the other Surrealists, Miró painted only shapes and colors from his imagination. Here, a mysterious deep blue provides a backdrop to weird black, white, red and green shapes that conjure up all sorts of unusual and interesting associations.

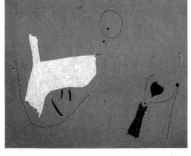

Reference

Top: grinding pigment and oil to
make paint; filling the tubes. Middle:
repairing a tear in a canvas; damping
down bulges; cleaning the painting.
Bottom: making and staining the
frame.

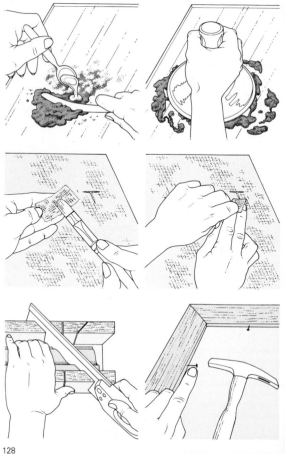

Having mastered the basic elements of the art of oil painting, many people feel tempted to explore the related craft. On the following pages you will find alternative materials and methods of preparing and executing your work. These recipes for grounds, oil paint and varnishes, among others, take the art of painting one step further, while the experience to be gained from preparing homemade materials, experimenting with them and benefiting from their different qualities, gives a painter more control and understanding of the end result.

Interest aside, doing it yourself is always an economical measure, although it demands patience to develop the correct technique. Practice is the only way to master any of these skills but be aware of the dangers of being diverted by them from the real business of painting.

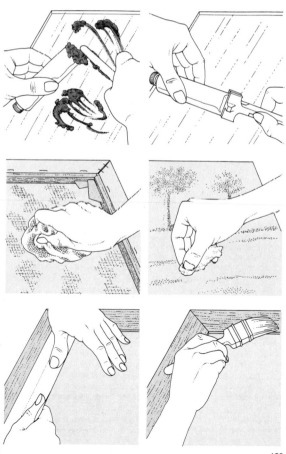

Recipes and canvas care

Keep a set of containers and utensils solely for preparing mixtures as most of these ingredients can be harmful. Keep turp away from a naked flame and store in glass bottles or jars as it will eat through plastic. NB Stick some gummed tape up the outside of a jar and mark it at regular intervals to use as a guide for measuring out quantities for recipes.

Rabbit skin size

Use rabbit skin granules rather than sheets as they are easier to measure. Put 2½oz granules into two pints of cold water and leave overnight. Next morning spoon it into a double boiler and warm until dissolved. Do not allow it to boil as it will lose its sealing qualities. Always use lukewarm. More granules can be added if it is too weak. Size will keep for four or five days in the refrigerator and twice as long with the addition of a few drops of vinegar. This recipe makes a large quantity of size which you will need if you intend to prime a number of canvases and panels.

Making gesso

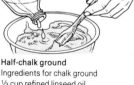

Chalk ground
1 cup warm size
1 cup whiting (chalk)
1 cup titanium white powder
Sift and mix dry ingredients. Gradually pour in warm size, stirring constantly until it reaches a thin, creamy consistency. This mixture has no flexibility and is only suitable for panels.

Half-chalk ground
Ingredients for chalk ground
⅓ cup refined linseed oil
Make up a recipe for chalk ground. Add linseed oil drop by drop, stirring with a spoon trying to prevent the mixture from curdling. The gesso will thicken if allowed to cool. Heat gently over a bowl of hot water to thin. Use on canvas or board.

Applying gesso to a board

Size the board and sandpaper lightly. Apply one coat of warm gesso; scrub in with a brush and rub with fingers. If bubbles develop at this stage they will persist to the final coat. Allow to dry thoroughly, or the next coat will lift the previous one. Reheat the gesso and apply the second coat evenly with a varnishing brush from left to right, starting at the edge of the board. Apply up to four coats, depending on the absorbency required, in alternate directions. Allow to dry, rubbing gently with fine sandpaper between each coat. (For a textured surface stipple the final coat with a stiff brush when still damp.) To test when dry put a wet finger on the surface. If the wetness evaporates it is ready; if it is too absorbent, give a final coat of size. Fabric-covered board (see p17) tends to soak up the gesso and will usually need this final coat. Dry at room temperature in daylight.

Mediums

Having mastered the use of linseed oil and turp with your paint, try using
different oils and vary the proportions you use. Sun-thickened oil is pale, thick
and fast-drying; stand oil is more viscous and makes the paint more fluid to
handle; it is durable but yellows in time. Both these linseed-based oils can be
thinned down with linseed oil and turp. Poppyseed oil is often used in the
manufacture of paint. It is a pale, slow-drying oil that does not yellow as much
as linseed oil but tends to crack more easily. Damar varnish can be used as a
medium (make up by adding 50% more turp to the recipe on p132).

A mixture of two parts sun-thickened or stand oil, four parts turp and one part
damar varnish is recommended if you want the paint to 'stand up' from the
canvas.

Beware of adding too much turp or other diluents to the paint as this will thin
down the oil and pigment, resulting in a washy appearance. It will also make
the paint dry too quickly. However, you could add more than normal when
painting on holiday. The painting dries faster and can be worked on each day.
Try to find a mixture that allows you to paint at your own pace.

Sun-thickened linseed oil can be made by adding
one part water to one part linseed oil in a wide glass
container. Keep dust-free covered with a sheet of
glass but allow air to pass over the liquid. Place in
sunlight and shake once a day for a week. Leave for
a few weeks until thick and pour off water.

Making oil paints

This is a satisfying, economical and relatively simple operation. The freshly
made paints are brighter, and the consistency can be altered according to how
much oil is incorporated and whether beeswax is added to give a richer quality.
Homemade paints have a stiffer consistency than the commercially prepared
paints which, nonetheless in artists' quality, are very good indeed. The
proportion of oil to pigment varies greatly (ie Naples yellow requires 15% while
Indian yellow requires 100%) so it is best to add the oil gradually until you have
the consistency you want. Some pigments can be difficult to grind (such as
viridian which will not mix easily with the oil); all are dangerous so wear a mask
and avoid the pigments that are most harmful (see p136).

1 Place pigment on a ground glass
slab. Add drops of linseed oil and mix
with a palette knife.

2 Grind in a circular motion with a
glass muller until the paint feels quite
smooth.

3 Store in airtight jars or fill tubes with
a palette knife and crimp ends
together with canvas pliers. Clean the
glass slab and muller with regular
turpentine.

Varnishing

A painting does not dry thoroughly for nine to twelve months, depending on the thickness of the paint. It should be allowed to dry naturally in daylight before varnishing or it will develop a cloudy 'bloom'. Heavy-handed varnishing can change the surface of the painting, giving it a dark, glossy sheen which may not be desired; it will, if done properly however, act as a protection against dirt, moisture and temperature and prevent pictures from losing their freshness and color. There is a wide choice of commercially prepared products as well as recipes for homemade 'picture' or 'finishing' varnishes that have different properties affecting the mat/gloss qualities and permanence. Damar picture varnish gives a low gloss, copal dries hard to a high gloss, synthetic varnish is reliable and will not yellow, and beeswax is useful as a second varnish to reduce the glossy finish of other varnishes. NB Retouch varnish is only a temporary picture varnish, but it will also bring up sunken patches of paint which occur naturally when working on a picture over a long period.

Applying varnish

Varnish on a dry day, in a dust-free room using a dry brush, having dusted the painting front and back. Pour the varnish into a shallow container and leave in a warm place for half an hour to drive off the moisture. Lie the painting flat. Apply one coat of varnish evenly with a fine-haired brush in 4in squares. Allow to dry overnight. A higher gloss will be achieved with more coats. For a mat surface gently rub on beeswax varnish with a cloth or brush and polish off with a soft cloth or piece of silk. Dabbing the still tacky picture varnish with a large, bushy brush will also give a mat effect. Varnish takes at least one month to dry. Spraying is not recommended, but if it is done, test for a fine spray (dilute with turp if necessary); make sure it does not drip, and apply three light coats.

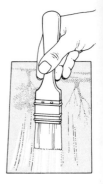

Making varnish

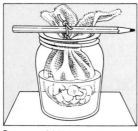

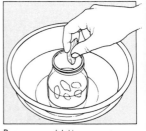

Damar varnish Use one part gum damar to three parts turp. Tie the resin in a muslin bag and suspend in the turp. Allow to stand for two days and strain the impurities through another piece of muslin. Store in an airtight bottle. To make damar medium use one part gum damar, one part turp, using the same method.

Beeswax varnish Use one part beeswax to one part turp. Break up beeswax into small pieces and add to warm turp in a glass jar sitting in hot water (not near a naked flame). Stir until dissolved. Store in an airtight jar. Beeswax should be employed as a second varnish; it can also be used as a painting medium if diluted with more turp.

Cleaning and repairs

The best way to avoid cleaning and repairing your painted canvases is, obviously, to take good care of them. Paintings should be hung in a steady room temperature as cold will crack the paint and too much heat will damage both the painting and the joints of the frame. Do not store paintings in the dark as this will cause the oils to darken over the years. Dust pictures frequently, front and back, to prevent the build-up of dirt. This is particulary important if the picture is not framed behind glass.

Minor repairs and cleaning can be done at home but it is best to leave anything serious to an experienced restorer. Varnished paintings can be cleaned lightly but take great care as water can do a lot of harm to a canvas. Try cleaning a painting with the middle of some newly baked white bread; rub small pieces over the surface and discard when dirty. Do not attempt any repairs on work other than your own and don't try to clean any recently painted or varnished surfaces.

Cleaning To clean varnished paintings wipe gently in a circular action with absorbent cotton dipped in a little mild soapy water and dry with a cloth. Cleaning emulsions are safer to use. Spread on with absorbent cotton and wipe off after two minutes; repeat if necessary. Try cleaning with bread (see above).

Removing bulges Place the canvas face down on waxed paper. Sponge the bulge with warm water. As the canvas dries the bulge will tighten. Allow to dry naturally. If the canvas appears a little slack, drive in the wedges.

Repairs Attempt nothing larger than a minor tear. 1 Cut a small piece of raw canvas of the same quality that will just cover the tear. Size it and the tear. 2 Lay the patch in place, making sure that the grain lies in the same direction, and smooth down with the finger. 3 Size again and allow to dry. Turn over and carefully prime the crack on the front of the canvas.

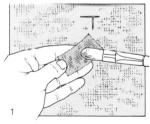

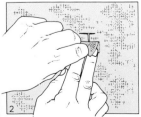

Framing

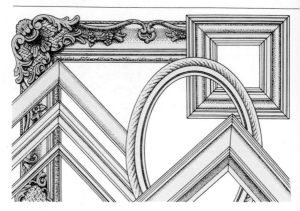

Although framing is not essential, it does enhance the qualities of the painting and also protects it. Choose a frame carefully; it should be in proportion to the size of the picture, sympathetic to the subject, color and style, and not detract from the painting.

Framing is a skilled craft in which accuracy is all-important, but it is as complicated as you make it. A method is given for making up a frame using equipment that any handyman might possess. Corner clamps, designed specifically for framing, provide a short-cut to ensure that corners are true.

Ready-made frames are available in standard sizes which you assemble yourself, following the directions on the pack. Ready-made moldings are available in approximately ten-foot lengths. Composition moldings should be cut by machine; those made from natural wood can be cut at home. They range from wide, elaborately carved moldings to a simple narrow *baguette*. A composite frame can be constructed by using two different moldings separated by a plain or colored panel. Builders' suppliers sell a wide range of basic moldings which may have to be adapted to make a frame by adding a rabbet but they are much more economical and can be decorated.

A painting can be glazed if it has not been varnished, although if hung in the wrong light it will reflect badly (especially dark paintings). Non-glare glass is not recommended as it tends to distort the image. Glass must not touch the surface of the painting; separate them with a fillet (a strip of wood or a thick cardboard mat between the glass and canvas which can be visible, or narrower than the frame and therefore invisible).

Cross-section of a molding

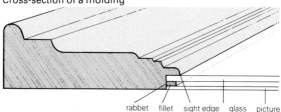

rabbet fillet sight edge glass picture

Making a frame

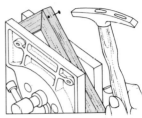

1 Measure all four sides of the frame. Mark out the lengths on the sight edge of the molding. Cut each piece at an accurate 45° angle in a miter box with a fine-tooth saw, on the outside of the mark.

2 Assemble an L with one short and one long side. Glue sawn surfaces, protect with cardboard and clamp in a vise. Pre-drill two holes and hammer in small nails. Assemble opposite L and then two Ls together.

3 Check frame is a true rectangle with a tri-square. Weight down under a board on a flat surface. When dry turn frame over and lay painting on rabbet (you should back a panel with masonite). Tap in nails to secure.

4 If you have backed the painting seal the crack between the board or stretcher and the frame with brown gummed tape. Fix screw eyes one third down on the back. Use wire or nylon cord to hang the painting.

Decorating the frame

To make the most of a natural wood frame such as oak or pine, sand to a smooth finish and apply a white wax polish. Staining will accentuate the grain. Use gesso as an undercoat or as a finished surface.

Gesso Apply two or three coats (see p130). Mix some dry pigment with titanium white and warm size. Brush on thinly and quickly while still warm. Rub in with a cloth. When dry polish with a soft cloth.

Gold For a gilt finish without using gold leaf use a 'gold' paste (such as Treasure Gold). Apply sparingly with a finger or soft cloth and buff up. Also use to disguise damaged gold leaf. It can be thinned with turp.

Storage

Materials

Canvas can be bought in bulk, rolled up loosely and stored in an airy room; it will keep for years in the right conditions. Ready-primed canvas can also be bought in bulk but test it first for proneness to yellowing. To do this, cut samples of various qualities in two; mark them and hang one in bright light, the other in the dark for three months. Do not fold primed or raw canvas.

Paint does not keep in prime condition indefinitely so do not buy in bulk unless you use large quantities and do not be tempted to buy paints reduced in a sale since they will probably be old. When you have finished painting for the day, squeeze the end of the tubes to get rid of the air, wipe the threads of the tube and cap and screw tight (see p23). Keep the labels clean so that you can identify the colors.

Brushes should be washed after every painting session (see p21). Never allow paint to dry on the brush and don't soak a brush in turpentine above the metal ferrule. Brushes can be stood in a jar, bristles up, but if putting them away for some time, make sure they are quite clean and dry and store them flat on corrugated cardboard in a box with a lid, protected with a few mothballs.

Finished work

Paintings should be stored flat if they are not going to be hung and it is best to take them off their stretchers and pin them to sturdy composition board. If you are transporting an unframed or unstretched painted canvas, sandwich it between two pieces of board and tie together with string. For a more temporary measure prop up stretched paintings and boards against a wall, facing inward; separate the moldings with pieces of cardboard. Tack a strip of wood to the floor about half a yard from the wall to stop them sliding. If you have to roll up a painted canvas wrap it around a large cylinder, paint side out, to avoid cracking the surface.

Sketches used as preliminary studies for oil painting should be fixed if they are charcoal or soft pastel, pencil or conté, or interleaved with tissue paper and then stored in a plan chest or portfolio. Keep all your sketches, however insignificant you feel they are. They will be useful for reference and future compositions.

Dangerous materials

The basic rule must be to respect your materials – most are harmful to some degree. Fix drawings in a well-ventilated room; do not mix pigments in the kitchen or any raw materials in cooking utensils; do not chew the handles of your brushes. Most important of all, do not allow children in your studio alone.

Pigments: dry pigments are dangerous to inhale. Some are poisonous, especially the cadmiums and chromes. Flake white is white lead; this should be used only as paint from the tube as it is highly poisonous; be sure to scrub your hands and fingernails thoroughly after using it.

Turpentine: store in the dark in a glass container (it will eat through plastic) and don't have it near a naked flame. Those allergic to turpentine should use mineral spirit as a substitute.

Varnish: natural and synthetic resins are highly inflammable and the fumes should not be inhaled.

Metric conversion table

Weight		Capacity		Size	
1oz	28g	½fl oz	14ml	1in	25mm (2.5cm)
2½oz	70g	1fl oz	28ml	12in (1ft)	305mm (30.5cm)
4oz	114g	10fl oz	284ml	36in (1yd)	914mm (91.4cm)
8oz	227g	16fl oz (1 US pt)	454ml	39in	1000mm (1m)
1lb	454g	20fl oz	568ml	60in (5ft)	1524mm (1m
2¼lb	1kg	2 US pt	1 liter		52.4cm)

Glossary

Aerial perspective See Perspective

Alla prima Painting directly on the primed or even unprimed canvas, rather than over a colored ground or over a dry underpainting.

Chiaroscuro (Italian, meaning light–dark) The play of contrasted light and shade, usually in the depiction of movement.

Complementary colors Any color is complementary to the color with which it contrasts most strongly, as red with green, yellow with violet, blue with orange. Complementary colors occur opposite each other on the conventional color wheel.

Cool colors See Temperature

Counterchange Interaction of contrasting tones or colors.

Earth colors Pigments obtained from clay or minerals rather than chemicals; they are less intense than synthetic colors.

Gesso Chalk- or gypsum-based ground applied to a board or panel, producing a smooth white surface.

Glaze Transparent or semi transparent layer of oil paint to add luminosity or to modify the underlying color.

Ground The prepared surface on which the painting is painted, either a layer of paint (sometimes tinted) or, in the *alla prima* method, the white primed canvas.

Hatching Shading or filling in with lines roughly parallel.

Hue Chromatic value of a color (as opposed to its tonal value).

Impasto Thick, opaque oil paint applied for expressive emphasis, usually for a highlight.

Key The general range of a set of colors. A painting has a high key of

color when its dominant values are bright and its hues are saturated.

Life painting Painting from direct observation of the model.

Local color The intrinsic color of a form, unaffected by reflected light or color.

Medium 1 (plural, media) The material or technique of a work of art. 2 The binder in which pigment is held, and hence the kind of paint – oil, tempera, acrylic. 3 (plural, mediums) Oils, waxes and varnishes added to oil paint to change its consistency.

Modeling The description of form by creating the illusion of solidity.

Modulation The gradual change of colors or tones.

Monochrome Strictly, in one color; usually, in black and white or brown or gray, without color.

Negative shape A term applied to the abstract shapes seen in the space between forms. The form may be called a positive shape.

Palette The board on which the artist arranges and mixes his colors; hence, also the range of his colors.

Passage Part, area or excerpt of a painting (as if from a book).

Perspective Conveyance or suggestion of distance in painting. Linear perspective involves the use of a vanishing point toward which receding horizontal lines converge. Aerial perspective is the suggestion of distance by tone, for instance using lighter and cooler colors as they approach the horizon.

Pigment The coloring substance in paint (as opposed to the medium or binder); simply color.

Plane Face or surface, understood as being flat and of two dimensions. An object can be painted as if it consisted

of several planes or faces meeting at different angles. Also used to describe areas of a composition, in the same way that foreground, middle- and background are defined. The picture plane is the surface of a painting.

Plein air A painting executed in the landscape to capture the impression of the open air.

Positive shapes See Negative shapes

Primary colors Red, yellow and blue are the primary colors, from which the secondary colors derive by mixing: red with yellow creates orange, yellow with blue creates green, blue with red creates violet. Mixtures of secondary with primary colors create tertiary colors.

Primer The first paint layer, either oil or acrylic, on which all subsequent paint layers are applied.

Reflected color The color of a form as modified by the light and colors around it (as opposed to local color).

Restating Changing and attempting to fix the position of an object in a painting.

Saturated color Color of full intensity with no white added.

Scumbling The overlaying of opaque broken color allowing the underpainting of a different color to be moderated or blended.

Secondary colors See Primary colors

Size Glue size (derived from animal hide or gelatin) is used as a surface preparation on canvas or board before priming.

Stain A wash of color that is absorbed by the ground.

Still life Painting of plants or animals, with or without other objects; loosely, any scene without figures that is not landscape.

Stippling The application of paint in flecks with the point of the brush rather than in continuous strokes; or any similar dotted effect.

Support Stretcher and canvas, wood panel, board and battening, or other material on which to paint.

Temperature A quality of color. Red is the hottest color, blue the coolest. Optically warmer colors seem to advance and cooler colors recede.

Tertiary colors See Primary colors

Tone Degree or quality of light or shade, hence dark tones, light tones, mid- or half-tones. Colors also may be dark or light and therefore possess a tonal value.

'Tonking' (from the English painter Henry Tonks) Technique of removing paint by covering an area with a material that absorbs most of the excess oil and surface paint.

Tooth Weave or texture of a canvas or other support (first used of paper).

Underpainting The initial layers or build-up of a painting, laid over the ground. Though often invisible in the finished work, it may crucially affect its colors.

Value Quality or degree of a tone or color. A color, such as red, may change its value and become, for instance, orange; or a color or monochrome area may have a certain tonal value, on a scale between light and dark. Where the term occurs without a context, it generally means simply tone.

Vanishing point In perspective, a point on the horizon toward which lines receding into depth converge.

Warm colors See Temperature

Index

Picture credits

34 The National Gallery, London; 35T The Art Institute of Chicago; 35C/
36T The Fotomas Index; 37T/B The Ashmolean Museum, Oxford; 38T/B
The Royal Academy of Arts; 39 Josef Albers/The Bridgeman Art Library;
40T/B Victor Pasmore/The Arts Council of Great Britain; 41René
Magritte/The Art Institute of Chicago; 43T The Tate Gallery, London; 49C
National Museum Vincent van Gogh, Amsterdam; 49B Scala; 53 The
Bridgeman Art Library (Henry Huntington Library); 58 Henri Matisse/The
Baltimore Museum of Art/The Cone Collection, formed by Dr Claribel
Cone and Miss Etta Cone of Baltimore, Maryland; 64T Pablo Picasso/
Private Collection/Scala; 64B Scala; 65T The National Gallery, London;
65C/B/66T Robert Bramwell-Jones/The Byam Shaw School of Art,
London/Photo: MB/Walter Rawlings; 66CR Edgar Degas/The National
Gallery, London; 66BL/BR Vicky Talbot-Rice/The Byam Shaw School of
Art, London/Photo: MB/Walter Rawlings; 69T Edgar Degas/National
Gallery, London; 69BL Euan Uglow/Browse & Darby Ltd/Photo: MB/Walter
Rawlings; 70 Claude Monet/The National Gallery, London; 71 The
National Gallery, London; 81 Edgar Degas/Courtauld Institute Galleries,
London; 83/84B Diana Armfield/Photo: MB/Walter Rawlings; 86T Edgar
Degas/Scala; 86C Claude Monet/Courtauld Institute Galleries, London;
87T Cliches Musées Nationaux, Paris/The Hamlyn Group Picture Library;
90T/C Archives Photographiques Caisse Nationale des Monuments
Historiques/The Hamlyn Group Picture Library; 90B Cliches Musées
Nationaux, Paris/The Hamlyn Group Picture Library; 92T Staatliche
Museen, Berlin-Dahlem; 92CL Carel Weight/Collection of Mr and Mrs
Jeffrey Horewood/Photo: MB/Walter Rawlings; 92CR Amedeo
Modigliani/National Gallery of Art, Washington, Chester Dale Collection;
92B Peter Greenham/Photo: MB/Walter Rawlings; 96B/98 Ken Howard/
Photo: MB/Walter Rawlings; 99T The Courtauld Institute Galleries,
London; 99C Ken Howard/Collection of Mr and Mrs Jeffrey Horewood/
Photo: MB/Walter Rawlings; 99B Marc Winer/Hunt Collection; 105B
Musée des Beaux-Arts, Strasbourg; 109 Bernard Dunstan/Photo: MB/
Walter Rawlings; 111B Edward Hopper/The Phillips Collection,
Washington DC; 112T The National Gallery, London; 113T The Tate
Gallery, London; 113B Marc Chagall/The Tate Gallery, London; 114 Scala;
115T The National Gallery, London; 115B Pablo Picasso/The Art Institute
of Chicago; 116T National Gallery of Art, Washington DC, Widener
Collection; 116B Scala; 117T Edward Hopper/Des Moines Art Center,
James D Edmundsen Fund 1958; 117B Pablo Picasso/The Tate Gallery,
London/Photo: MB/Angelo Hornak; 119T Marc Winer; 119B The National
Gallery, London; 122T Claude Monet/Louvre, Paris/Photo: Cliches
Musées Nationaux, Paris; 122C Claude Monet/The Art Institute of
Chicago; 122B Auguste Renoir/National Gallery, London; 123T The Tate
Gallery, London/Photo: MB/Angelo Hornak; 123C Henri Matisse/National
Gallery of Art, Washington DC, Chester Dale Collection; 123B Sonia
Delaunay/Musée National d'Art Moderne, Paris/Photo: Cliches Musées
Nationaux, Paris; 126T Boston Museum of Fine Arts, Henry Lillie Pierce
Fund; 126B Pablo Picasso/Cleveland Museum of Art, Gift of Hanna Fund;
127T Emil Nolde/The Tate Gallery, London; 127C Mark Rothko/The Tate
Gallery, London; 127B Joan Miró/The Tate Gallery, London.

Our grateful thanks to Mr and Mrs Horewood for granting us access to
their collection and to the Royal Academy, London for allowing us to
photograph a number of works exhibited at the Summer Exhibition 1981.